Merseyside
AT WAR

Anthony Hogan

AMBERLEY

This book is dedicated to my beautiful wife Suzanne and my wonderful sons Mikey and Sam. For their patience and understanding of what this subject means to me and their encouragement towards my research.

Also to the memory of Lauren Mae Robinson. The bravest little girl it has ever been my pleasure to meet, and the brightest star in the sky.

First published 2014

Amberley Publishing
The Hill, Stroud
Gloucestershire, GL5 4EP

www.amberley-books.com

British Library Cataloguing in Publication Data.
A catalogue record for this book is available from the British Library.

ISBN 978 1 4456 3760 0 (print)
ISBN 978 1 4456 3774 7 (ebook)

Typesetting and Origination by Amberley Publishing.
Printed in Great Britain.

CONTENTS

ACKNOWLEDGEMENTS

I would like to thank the following people for their help and input. Christopher Long at http://www.christopherlong.co.uk/ and Helen Long for their help with information and photographs about George and Fanny Rodocanachi. Maria O'Rourke, along with Christopher and Austin Muscatelli, for their input and pictures of the Muscatelli family. Ray Quarless for the information and pictures of Ernest Quarless. Ged Fagan, Egbert Sandrock, Martin Jones, Kev Keegan, John Forrest, Bob Edwards, Chris George, Mandy and Ella Robinson, Stan Boardman, Sue Hogan, Sam Hogan, Michael Rogers, Caryl Williams, Sabine Declercq Couwet and all the contributors who have allowed their stories to be added. Thanks also to the Great War Forum, WW2 Talk, Inacityliving, My Liverpool, Merseyside Genealogy and History group, and Yo Liverpool.

INTRODUCTION

A curiosity of who I was and where my roots lay had ebbed away at me until I finally took the plunge and began researching my family history. Irish and Swedish? Well, at least that explains my blonde eyebrows and freckles. All jokes aside, it became a fascinating insight into my lineage and one thing kept cropping up – the men kept dying at war. My grandfather died during the Second World War and two of my great grandfathers had fallen in the First World War. I was now further intrigued as to what they had done at war and researched them in detail. With much information obtained and a heart full of pride, that should have been that, but I was hooked. War memorials now grabbed my attention; the one standing within Our Lady of Reconciliation church in Eldon Street was my first project, quickly followed by St Anthony's church War Memorial on Scotland Road. Future projects would find me researching men listed on memorials on the churches at St Paul's on Derby Lane and St Anne's Stanley. I had gained huge satisfaction from my research into the stories of the men who had served and died; after all, they are much more than just names on a war memorial. However, it started me thinking about those who survived the wars, those who lived and worked through it and those who died as civilians. Did their stories not deserve mention as well? In 2009, I created the Liverpool and Merseyside Remembered website, a place for people to share their stories of loved ones who had lived through the two world wars. I was stunned by just how popular it became and must thank the many contributors who have made it what it is. My work has led to local media asking for my help on a number of projects, including interviews for TV, radio and newspapers. I have also been invited to participate in a number of local wartime events. I am no military expert; my interest lies in researching and collecting stories. I have made some very dear friends in the process, including my front-line pals Egbert in Germany and Sabine in Belgium, who continue to aid my research. For me, remembrance is everything; without these brave people who lived through such trying times, there would be no story for me to tell. They deserve our respect and remembrance.

Generals, leaders and politicians, I care little for them; my thoughts always lie with the common people, those who did their duty, performed amazing deeds and lived extraordinary lives through wartime. These incredible people do not have

their names reeled off in the media and no overhyped statues worship them, yet they have the remembrance and the pride of a nation, the thanks for our lives today and the knowledge that they will never be forgotten. Remembrance is everything; we could argue for months over the right and wrongs of war, yet it would change nothing. We cannot alter the past; what happened, happened, but we can remember and try to learn. I myself remember those from all sides. If we cannot put the past aside and become friends then we can never move on.

It is remarkable that in times of abject poverty in some of the poorest areas of the country, men, many voluntarily, laid down their lives for a freedom and democracy that they themselves would have had every right to feel was bypassing them anyway. There has always been the haves and the have nots, and none more so than in those dark, depressing years leading up to the two world wars. It is with heartfelt passion that I feel that those sacrifices cannot be stated enough. This book is here to recall the part that Merseyside people played during the two world wars and to give an insight into the lives they led. Of course, everyone cannot be included, and it has been a struggle to select some stories while having to leave others out. It is my hope that the people you will read about will stand as a remembrance to all the other Merseyside people who served, worked or lived through such trying times.

On 4 August 1914, Britain declared war on Germany and, for the next four years, the First World War would continue – a horrific episode in the world's history. It would claim the lives of millions of people, maim and injure thousands more, and deprive families of their loved ones. David Lloyd George had promised the enlisting men that they would return to 'A land fit for heroes'. What most of the returning men came home to was a small cash payment, a civilian suit and a pair of medals. They then had to join the masses looking for work and often their search was in vain. Injured men received a small pension yet had little chance of employment. These men had fought bravely for King and country, yet returned home to unimaginable hardships. Their biggest fight had started – the fight for their survival and their families'.

Following the outbreak of war, the men of Merseyside took the call to enlist. Many joined the King's Liverpool Regiment or chose to opt for other local regiments, such as the East Lancashire, the Cheshire, the South Lancashire or the Loyal North Lancashire regiments. Others chose Irish, Welsh and Scottish regiments with connections to their history, while others signed up with whoever would have them, especially those who were underage and determined to join up. A number chose to serve at sea as Mercantile Marines or with the Royal Navy. They would all face dangerous times in foreign lands and waters, witness terrible events and fight in some of the bloodiest battles ever known. Inevitably, some would never return home; they would pay the ultimate sacrifice with their lives.

As well as the battalion HQs, many recruitment centres sprang up where men could enlist for service, thus answering Kitchener's call of 'Your Country Needs You'. Lord Derby proposed recruiting a battalion of 'Pals' for the King's Liverpool regiment, suggesting that men who worked together could fight together. Within

a week thousands of men had signed up for the Pals Battalion at the old watch factory in Prescot. The 17th, 18th, 19th and 20th Battalions of the King's Liverpool regiment were created and became the Liverpool Pals, the 17th having the distinction of being the first of the Pals Battalions in the country to be formed. More Pals Battalions sprang up as enlistment fever gripped the country. Most of these men would face their baptism of fire on 1 July 1916, on the first day of the Battle of the Somme; until then, the regular, militia and territorial soldiers would mainly fight the war.

Why did so many rush to enlist? Patriotic fever that was fuelled by German propaganda; the belief that the war would be over by Christmas and if not then, soon after; the chance to travel; regular pay; an escape from the poverty of life; or just the excitement of it all. Today, we know that thousands of young lads who were underage signed up and served their country, many saw action in some of the most brutal and horrific battles ever known, many were wounded and many died. It happened, there is nothing we can do about it now; most of these boys were determined to join up and they did. Life in 1914 must have been pretty mundane for a young lad – there were no televisions, mobile phones, games consoles or the Internet back then, just the same old everyday routine. Then a war starts. The glamour, the passion, the adventure – imagine how it must have seemed to them. They would see the local men marching off, everyone cheering, and they wanted that as well. Sadly the reality was not what it had first appeared, and they found themselves in the middle of unimaginable horrors.

The war was not over by Christmas 1914. It fell into a stalemate of trench warfare that would last another four years. It left us with names that history would never forget: Mons, Verdun, Somme, Ypres, Marne, Cambrai, Loos, Gallipoli, Jutland, Pozieres, Guillemont, Arras, Messines and Passchendaele to name but a few. It also provided us with millions of dead servicemen and civilians; the scale of the casualties during this war was horrific. This was a war of technology. The weapons were much more devastating and made to cause maximum damage – the world had seen nothing of its like before. It was called the 'war to end all wars', yet just over twenty years after its end, a second world war would begin: a war with further improved technology, a war that brought out the evil in humans on all sides.

We should not forget the roles that women played in the two world wars, from nursing at home and close to the front lines, to munitions making, land army agriculture, ship building, furnace stoking, factory work, fire fighting, tram driving and ambulance driving. Basically, the women took on the roles that were left by the enlisting men; often, they were better at it. Many women did this work while raising families and worrying about their menfolk at war. Never underestimate the role of women during the wars; without them, the men would not have been able to fight.

By 3 September 1939, Britain was again at war with Germany – this time for the best part of six years. Within days, thousands of men had received their enlistment papers as Britain prepared its forces. Technology had advanced beyond recognition

of the First World War; it included the evil bombing raids made by all sides upon defenceless civilians. By its end, millions had died and the world had been left with a reminder of how brutal humans can be to each other.

The people of Merseyside played their part in the two world wars. Their ability to cope with endless sorrow and hardship, their strength to carry on, their bravery and defiance to face whatever challenged them at home or abroad, their spirit and, at times, humour. These are your heroes. We should never allow the memory of them to slip away. We should be proud of them and preserve their stories for our future generations. It is my hope that this book will go some small way towards ensuring that they are remembered.

CHAPTER 1

THE LADS THEY WENT TO WAR

Bite on your lip, think of your mam
Good luck lad bide thee well
And make your peace with Jesus
As they send you into hell

The British Expeditionary Force (BEF) were the first to be sent out to face the German Army. They consisted mainly of regular soldiers and ex-servicemen who had remained on the reserve list. As the war ground on, they were followed by the volunteers and conscripts. Alongside them were the Navy, Royal Flying Corps and the Merchant Navy; add the doctors, nurses, Labour Corps and many more, and you can see the scale of the people that were needed overseas. It is estimated that over 10 per cent of Britain's First World War dead came from the North West of England, which shows the huge sacrifice that this area made. Back home, people were needed to run the country. It was the women who stood up to be counted and took on the jobs, while many men were denied the chance to serve, as their trades were considered important to the war effort. This really was a war that included almost everybody; nothing like it had been seen before. The men of Merseyside went off to war and they would produce thousands of personal stories. The following pages include a small number of these stories; hopefully they stand as a remembrance to all those who served.

How it must have felt to lose a child to war I cannot imagine – hopefully I will never find out. Yet thousands of mothers and fathers would endure this terrible experience during the First World War. Thomas and Bridget Fagan of No. 107 Gildarts Gardens, Liverpool, knew this feeling very well as they experienced it three times. The loss of their sons James, Michael and Christopher must have torn their lives apart – you just cannot begin to understand their sorrow. I have no right to judge events that I had no part in, but I do believe that losing three of your boys should never have been allowed to happen.

The first son to fall was Michael Fagan on 10 March 1915, aged thirty-two. Michael was married to Catherine McCool in Liverpool in 1905. He had served in South Africa before rejoining the Army at the outbreak of the war – Sgt Michael

Fagan 7872, The King's Liverpool Regiment 4th Battalion. Michael is remembered at the Le Touret Memorial in France. The second son to fall was Christopher Fagan on 30 May 1917, aged twenty-four. Christopher was married to Ellen Jordan in Liverpool in 1914. Gunner Christopher Fagan 108741, Royal Field Artillery V/38th Trench Mortar Battery is buried at Bard Cottage Cemetery in Belgium. His commanding officer described him as, 'A brave and steady soldier, who was ever willing to do his duty.' He left a wife and a child. The third son to fall was James Fagan on 11 October 1918, aged thirty-eight. He enlisted on 12 August 1914 and was discharged in 1916 with sickness. James was unfit for service and was sent home, but his illness would claim his life two years later. James was married to Elizabeth McCool (the sister of Michael Fagan's wife Catherine), who he married on 9 December 1902 at Our Lady of Reconciliation church in Eldon Street. Pte James Fagan 10947, the King's Liverpool Regiment 3rd Battalion is buried at Liverpool Ford Cemetery.

Michael Cooney, aged forty, and his son also Michael, aged twenty, both perished on the sinking of *Lusitania* on 7 of May 1915. Elizabeth Cooney was left a widow, mourning her husband and her son. How she coped we can only guess, but by mid-1918, her suffering was over and she passed away in Liverpool. This is a tragic story of how the sinking of the *Lusitania* destroyed a family. The family had lived at Hopwood Street in Liverpool and both Michaels had served as firemen on the *Lusitania*.

William and Gertrude Clough of No. 48 Derwent Road, Liverpool, had two sons serving during the war. Gordon was serving as rifleman 1894 with the 1st/6th Battalion of the King's Liverpool Regiment when he was killed in action, aged twenty, on 5 May 1915 at Ypres, Belgium. He is remembered on the Menin Gate Memorial. William Clough, the brother of Gordon, was serving as a fifth engineer officer, mercantile marine with the SS *Feltria*. He was returning from the USA to Avonmouth when the ship was struck by a torpedo 8 miles off the coast of Waterford, Ireland. The ship sank with the loss of forty-five lives, including William, who was just twenty-four. The sinking happened on the 5 May 1917, two years to the day that Gordon had been killed in Ypres, a cruel anniversary for their parents.

George Skilandis served as Pte George Smith 5391, Royal Welsh Fusiliers 1st Battalion, dying of his wounds on 26 May 1915, aged twenty-one. He was the son of George and Magdelena (Mary) Skilandis of No. 118 Portland Street, Liverpool, both his parents born in Russian Poland. George served under the name 'Smith'. It was not unusual for men to serve under assumed names; many seem to have done so because they had foreign-sounding names. His mother must have returned the Final Verification forms to the CWGC because she gave her own name and address as next of kin. For whatever reason, she didn't correct the false surname in the official records, but did when it came to the newspapers and the local memorial. George is buried at Longuenesse Souvenir Cemetery in France and remembered on the war memorial at Our Lady of Reconciliation church in Eldon Street. His brother Anthony was killed during the Second World War on 7 February 1943, while serving aboard the SS *Mary Slessor* as a greaser.

Peter John Farrelly was born in Manchester in 1867, and lived in Ashton in Makerfield. As a boy he drove ponies in the coal mines. It seems that, as Peter looked at his life, he saw no future in the mines, deciding instead to chance the Army. Peter was in and out of the Army, leaving, deserting, rejoining. This was not unusual back then and the Army tended to take the view that if they thought he would make a good soldier eventually, they would hang onto him and thereby get some benefit from the money spent on his training, so he must have been considered a good soldier. He served during the Boer War before moving to Ireland, where he met and married his wife Sarah. In 1903, Sarah, by now heavily pregnant, made the journey to Liverpool by boat. On the voyage she went into labour and gave birth to their first child, a daughter also named Sarah. The baby was given Dublin/Irish nationality, and three other children, Peter, Annie and Mary, were later born in Liverpool.

Peter had enlisted as a gunner with the Dublin City Royal Garrison Artillery in 1903. He was promoted to bombardier in July 1905, before being transferred to the Lancashire Royal Garrison Artillery in June 1906, where he was promoted to corporal a month later. In April 1907, Peter left the Army. Peter's wife Sarah suffered from a mental illness, which explains his transfer to the Lancashire Regiment, allowing him to be close to her and the children. Peter used his experience to gain promotions so he could earn more money to help his family. On his discharge, he returned to his home at Beacon Street off Blackstone Street, alongside the docklands of the Vauxhall area of Liverpool, where he found work as a dock labourer. The family later moved to close by No. 3 Fulton Street.

In 1914, Peter, being an old soldier, was enlisted again – this time with the Royal Dublin Fusilier 2nd Battalion as Pte 13502. His regiment went straight to France, arriving on 22 August 1914. Peter saw his first action on 26 August 1914 at Le Cateau, where his regiment helped delay the German advance on Paris. He also took part in the retreat from Mons. By April 1915, Peter and his regiment were in the Ypres sector in Belgium, waiting to be sent into attack. The attack happened on 25 April. When the Dublins came out of their trenches to attack the Germans, they were met by machine gun and rifle fire, along with heavy shelling. Fighting through barbed wire, they managed to make it to the outskirts of Saint Julien and occupy the ruins before digging in a 1/4 mile from Saint Julien. They had helped secure the line, but their losses had been substantial. The following day, they again attacked the Germans at Saint Julien. Sadly, Peter was killed during this action; he was forty-seven years old, and left his wife Sarah and four children back home in Liverpool. Peter has no known grave and is remembered on the Menin Gate Memorial. He is also listed on the St Alban's First World War Memorial that is now located in St Anthony's church on Scotland Road, Liverpool. Sadly, due to her illness, Sarah found it hard to cope and the children spent a lot a time in orphanages; they never really knew their parents. Sarah passed away in November 1925 and the address given showed she had still been living at No. 3 Fulton Street.

Michael McKenna served as Shoeing Smith TS/2002 with the Army Service Corps Secondary Regiment, Royal Fusiliers. He was married to Martha, with

whom he had two children, the family living at No. 499 Prescot Road, Old Swan, Liverpool. Michael worked as a shoeing smith at No. 111 Arundel Avenue, Martha as a confectioner. Michael sailed aboard the *Ultamatia* from Southampton on 18 January 1915, arriving in Havre the same day. After home leave he returned to France, and on 25 October 1915 he left Marseilles for Egypt, arriving in Alexandria on 20 October. He remained there until 22 November 1915 when he sailed for Salonika. On Christmas Day 1915, Michael and some friends had a few drinks to celebrate. He left around 9 p.m. a little drunk, but appeared sensible. The following morning he was not in his tent and a search took place for him. Michael was found face down in a stream; he had walked over a cliff edge before falling into the water. He was buried at Mikra British Cemetery, Kalamaria, Greece. The Army investigated the matter, concluding that Michael had died from concussion followed by suffocation, resulting from a fall by misadventure. They also refused Martha a pension for herself and the two children, as Michael's death had not been during military duty, although this was overturned in July 1916.

William Barker was the son of William and Mary Ellen Barker of No. 107 Wood Street in Birkenhead. Billy, as he was known, was killed in action on 8 August 1916 at Guillemont while serving with the 1/5 Battalion, Kings Liverpool Regiment. He had enlisted on 17 August 1915 and, after training, he was sent to France on 10 February 1916. He was aged just nineteen when he died. He has no known grave though he is commemorated on the Hamilton Square Memorial in Birkenhead and the Thiepval Memorial in France. After his death, members of his family acted as if Billy was still around; those who really had little memory of him or who were born after his death got to know his likes and dislikes, just as if he was still there. In his mother's eyes he still was, and that is what she wanted.

William Henry Beckley was born in Liverpool in 1989. He would be awarded the DCM medal during the First World War. William had served as Bdr 53448 with the Royal Garrison Artillery 12th Heavy Battery. The *London Gazette* mentioned his award on 16 May 1916: 'Distinguished Conduct Medal, awarded to 53448 Gunner. W. H. Beckley, 40th Trench Mortar Battery, R.G.A. For conspicuous gallantry. When a live bomb fell in his emplacement he immediately picked it up and unscrewed the fuse, which exploded as he threw it away. This prompt action certainly saved casualties.' His luck ran out later that year when he died from his wounds on 31 July 1916 after fighting in the Battle of the Somme. William was just twenty-eight years old when he died in a field hospital close to Dive Copse Wood, near the village of Sailly-le-Sec in France. He is buried at Dive Copse British Cemetery.

Alfred Turner was born in Liverpool in 1900 to Alfred and Mary Ann Turner. His father Alfred was born in Liverpool and ran a number of coffee shops in the city. His mother Mary Ann was born in Kendal to a Scottish family and she also helped run the coffee shops. In 1911, the family was living at No. 16 Stanhope Street in Liverpool. When the war broke out in 1914, it had a big effect on young Alfred; he wanted to join up and serve, and not miss out on this exciting episode. He was of course too young to join, but like other young lads, he was determined.

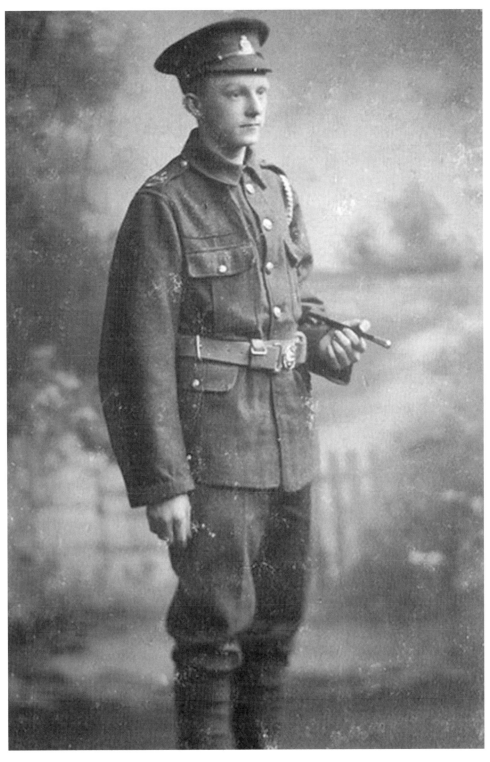

Alfred Turner.

We now know that many underaged boys managed to fool the recruiting officers or get them to turn a blind eye so that they could serve in the great exciting war. We also know that their experiences turned out to be something that they could never have expected or imagined. Alfred managed to get himself signed up. The family are unsure of his regiment or even if he used a false name, but they do know that in 1916 he was acting as a stretcher-bearer during one of the most horrific battles of all time. Alfred, not yet sixteen, was serving on the Somme. His father found out his son was serving abroad and contacted the Army. He managed to get him located and then returned home, thankfully in one piece. Alfred's war was over. He later worked as a tram and bus driver around the streets of Liverpool.

Sgt David Jones, 12th Battalion King's Liverpool Regiment, was awarded the Victory Cross for

> most conspicuous bravery, devotion to duty and ability displayed in the handling of his platoon. The platoon to which he belonged was ordered to a forward position and during the advance came under heavy machine gun fire, the officer being killed and the platoon suffering heavy losses. Sgt Jones led forward the remainder, occupied the position and held it for two days and two nights without food or water, until relieved. On the second day he drove back three counter attacks, inflicting heavy losses. His coolness was most praiseworthy. It was due entirely to his resource and example that his men retained confidence and held their post.

On 6 October 1916, David received word that he was to be awarded the Victoria Cross for his actions in Guillemont on 3 September and was given the choice of returning to England to receive the cross or to go into action the following day. He chose the latter and was killed during the action on 7 October 1916.

David was born in Liverpool on 10 January 1891. He was a pupil at Heyworth Street School in Everton and the school mounted a plaque in his honour. His widow was presented with his Victoria Cross by King George V at Buckingham Palace on 31 March 1917. She decided to give the cross to J. Blake & Co., motor company, where David had been employed as an apprentice coachbuilder before war broke out. The decision was made when she heard that a representative of the company had been elected each year to take a wreath at the Cenotaph ceremony in London in his memory. The Victoria Cross, along with other memorabilia, is now held at the Museum of Liverpool.

This is a transcript of the letter written by Pte George Williams 12th Kings Liverpool Regiment, sent from Rolleston camp in Sheraton Salisbury, to his family at No.7 Bessemer Street, Dingle, on 12 December 1916.

> Dear Mother and Father. Just a few lines to let you know I am keeping well in heart but not in spirit, I have felt proper miserable these last few days, near everyone in the battalion is completely fed up with it, in fact they are running home on their own, but they suffer when they come back. It would break a lions heart never mind a man. I don't feel anyways homesick but it is the idea, the way they treat us, and furthering

us in places like this miles from no where, no town where we can pass a few hours. They have sent territorial's out to the front before us, I think we are as good to go out as they are, and I think that the Pals are all put in big towns, if I had my way I would put them all in a glass case. I wish they would send us out to the front, it cant be any worse than you had - we are going all this for 1/- a week. It is a bit cowardice of me to send you a letter like this, but I cant help it, I don't suppose you can image what we are going through. Its a matter of come off parade about 4, and then sit in a room waiting for next morning to parade again. I am glad S.A is doing well and so is her baby girl, it is a good job it is not another one of Kitcheners innocent victims, I suppose Maggie Roe is a bit jealous now. For goodness sake don't let John Henry join the army, I am going through it without two of us, I am just glad our Roby is not going through it, it is enough to make a mans life not worth living, plenty of fellows have turned to drink to pass the time away, but if it kills me I will never turn to drink. I could have told you all this long ago, but I cant hold it back now, you may think I am a bit of a coward but I am not, I cant describe my feelings to you so I will say Good night to you. from your loving son, George.

The 'S.A' in the letter is his sister Sarah Ann Roe, Maggie Roe was his niece, and John Henry was his brother who did join the Army and died of his wounds on 22 October 1917 at home. Roby was too young to join up and lived a long, happy life. George died on 21 February 1917 in Flanders. He was Pte 18030 when he sent this letter and had been promoted to lance corporal by the time of his death. He is buried at the A. I. F burial ground at Flers, in France.

Pte William Duffy 48851, The King's Liverpool Regiment 12th Battalion, was killed in action on 7 March 1917. William was educated at St Alphonsus School, St Francis Xavier's and Hammersmith. At the time of joining the Army, he was a schoolmaster at Eldon Street School. He was a member of the A. O. H, the Irish club and the Gaelic league, as well as holding the position of deputy organist at Our Lady of Reconciliation church in Eldon Street. William was a most enthusiastic Irishman, whose aim was to bring to the notice of the Irish people the beautiful Irish ballads and music. The MP J. D. Nugent wrote, 'His loss was a severe one not only for his parents, but to the Nationalist of Liverpool. Who where personally attached to him. R.I.P', in a letter to William's mother, who lived at No. 196 Commercial Road. His officer in command wrote 'Your son always performed his duty well, and was held in great esteem by all ranks of the battalion for his good comradeship and cheerful disposition. Whilst attending to a wounded comrade he himself received a fatal wound.'

John Thompson Reay was born in Birkenhead in 1868 to Matthew Dunn Reay and Isabella Thompson. He married Frances Rimmer in Liverpool in 1891. The couple had nine children of whom five sadly died young. John worked as an iron keg and drum maker and, just before the outbreak of war, the family were living at No. 8 Mansfield Street off St Anne Street. John signed up for service as Pte 23711 with the Liverpool King's Regiment. He was in his late forties when he signed up and the King's Regiment probably considered him too old for service overseas,

so he was transferred to the Royal Defence Corps (RDC) as Pte 19434. The RDC was made up of old soldiers who were beyond the age set for combatant service or those who were not fit for duty overseas, sometimes as the result of wounds received on active service. The Corps was similar in some ways to the Home Guard of the Second World War. Its job was to guard railways, tunnels, roads and ports, thus relieving other troops for front-line service. Through injury or illness, John was later moved to the Fusehill War Hospital in Carlisle, where he died on 20 May 1917, aged forty-nine. He is buried at Dalston Road Cemetery in Carlisle.

Pte James Cawley 2035, Australian Infantry, A. I. F, spent his early years living in Burlington Street before leaving Liverpool for Brisbane, Australia, where he married his wife Mary. James enlisted in Brisbane on 31 May 1915, arriving at the Gallipoli peninsula on 8 December 1915, before moving to Mudros on 9 January 1916. By March he had joined up with the B. E. F, before sailing to France, where he arrived on 19 March 1916 at Marseilles. On 26 May 1917, James was admitted sick to hospital with gonorrhoea; he stayed for forty-one days before rejoining his battalion. On 8 August, he was given two weeks of leave in England. Did he make it back to Liverpool where his mother was still living? James was killed in action on 21 September 1917 in the front line at Polygon Wood, Belgium. He is remembered on the Menin Gate Memorial in Belgium, and on the war memorial at Our Lady of Reconciliation church in Eldon Street. After his death, some confusion seems to have started, with enquiries being made into whether he was a deserter. His colonel submitted evidence stating that James had been killed just a few feet from him when they were in action. His friend, Martin Hassett, gave a statement saying how he himself had informed James's mother and wife of his death. He ended his statement with these words: 'I do not think there is any need of his description as I have known him since childhood. So whoever is enquiring about him, tell them that I lost my best friend when he left this world.' Charles Cawley, the son of James, served with the Australian Artillery as a gunner during the Second World War. He enlisted on 19 November 1941 and was discharged on 29 June 1942 – we can assume he must have been injured.

Philip Cain signed up with the King's Regiment on 1 September 1914 in Liverpool. On 17 December 1915, Philip was admitted to hospital suffering from shock, returning to his regiment on Christmas Eve. He was admitted again on 21 June 1916, spending seven days in hospital. On 31 August 1916, Philip was to face a very serious charge. While in the transport line, Philip received a gunshot wound to his foot. There was no witness to the incident and nobody was near him at the time. An inquest was ordered to find out what had happened. Philip was charged and, on the 4 October 1916, found guilty of self-inflicting the wound. He was sentenced to ninety days of field punishment No. 1. This consisted of heavy labouring duties, possibly being restrained in handcuffs or fetters and being tied to a post or wheel.

Philip returned to his regiment and carried on fighting this horrific war. On 5 October 1917, his commander reported that Philip had been buried by soil during heavy shelling on the night of 19/20 September. Philip survived and, on

26 September, his commander noted that the section was subjected to a very heavy bombardment, during which Pte Cain was much shaken. In action on 30 November 1917 during the Battle Of Cambrai, Philip was reported as missing presumed dead. Philip was clearly suffering from some sort of breakdown, yet he remained in action. If he did inflict his own wound then he must have been in total despair; he was a sick twenty-one-year-old man who was tied up for long hours during his ninety days of punishment, then sent back to fight. Thankfully we seem to have learned a lesson from the experiences of people like Philip. He and others have helped to change attitudes in this world towards this type of illness. Philip is remembered on the Cambrai Memorial, Louverval, France.

Thomas James Brislen was born in Liverpool on 2 December 1886. In 1901, he was living with his parents James and Annie, along with his siblings, at Petton Street in Everton. He married Annie Welsby at Our Lady Immaculate church in Everton in 1907. The couple had five children together and set up home at No. 19 St Domingo Road. Thomas was employed by Messers J. Bibby & Sons at King Edward Street in Liverpool before he enlisted with the 4th Battalion of the King's Liverpool Regiment, with whom he left for France on the 4 March 1915. On 18 August 1916, Thomas and his regiment left their trenches at Bazentin on the Somme to attack the German front lines. During the fight, Thomas went to the aid of many wounded men; he was later awarded the Distinguished Conduct Medal for his bravery that day. On 10 April 1918, Thomas, by now a corporal, boarded at train at Ambrines in France en route to Caestre. As the train neared Chocques, it was hit by an enemy shell and the casualties were high. Thomas was one of those killed that day, though it is uncertain if he died due to the train attack. Thomas Brislen is buried at Lapugnoy Military Cemetery, France. He is also remembered on the war memorials at Christ church, Everton, Our Lady of Immaculate Conception, Everton and J. Bibby & Sons, Bootle.

Tom McIntosh has the honour of taking Middlesbrough FC to their highest ever league position – third in the 1913/14 season. McIntosh's spell as manager was interrupted by the First World War. After only two seasons, he returned after the war for a short while before a move to Everton. At Everton he was most famous for spotting and signing Dixie Dean. Under McIntosh's guidance, Everton won the FA Cup and Football League Championship. He died from cancer in October 1935, and was eventually replaced as secretary manager at Everton by Theo Kelly. Tom joined the 12th Service Battalion of the Yorkshire Regiment, known as the Teeside Pioneers. Before long he was promoted to company quarter master sergeant. He later received his commission, becoming a 2nd lieutenant, and was mentioned in despatches twice. When you Blues go the match and see Dixie's statue, remember it was good old Tom McIntosh who signed him for you.

No. 12 Arnold Grove in Wavertree, Liverpool, is the birthplace and early home of Beatle George Harrison, yet the house holds another story that should be told. William Coleman enlisted into the 20th battalion of the Kings Liverpool Regiment on 25 May 1915 as Pte 29172, giving his age as seventeen years and his address as No. 12 Arnold Grove. On 30 March 1916, he sails from Folkestone

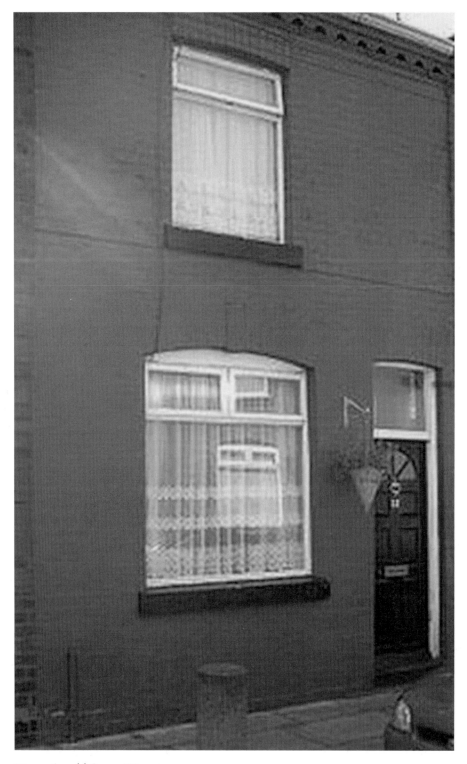

No. 12 Arnold Grove, Wavertree.

to France aboard SS *Invicta*. The 11 November 1916 sees William leaving Le Touquet, France, for England. Once there, he is transferred to The 4th Northern General Hospital in Lincoln, suffering from trench foot. He spends eight days in the hospital. He returns to France on 30 May 1917, then, on 29 March 1918, he is transferred to the North Staffordshire Regiment as Pte 41818 (basically, they were boosting the Infantry for attack, and William was selected). Just seventeen days later, William went missing in action presumed dead on 15 April. His body was later found and he was buried at Bailluel Communal Cemetery Extension in France.

Pte John McKenna 40187 of The Loyal North Lancashire Regiment 2nd Battalion (formerly 30959 Manchester Regiment) was killed in action on 1 August 1918. The son of Mrs E. McKenna of No. 41 Epsom Street, Liverpool, John is buried at Raperie British Cemetery, Villemontoire, France, and remembered on the war memorial at St Anthony's church, Scotland Road. John had enlisted in Liverpool on 11 October 1915, joining the 1st Garrison Battalion Manchester Regiment four days later at Knowsley.

Now, John's records show he was a bit of a lad and not much bothered about Army life. I have to admire him, as it looks like he was going to do the war his own way. He trained in Knowsley and, on 2 March 1916, he was awarded fourteen days confined to barracks and fined eight days' pay for being absent without leave from 20 February to 28 February 1916, thereby being absent from his regiment when they proceeded overseas. During his absence he was transferred to the 2nd Garrison Battalion Manchester Regiment. John stayed in Knowsley but has no intention of changing his ways, and was again in trouble on 26 April 1916, when he was charged with being absent from 22 to 25 April. He was fined three days' pay along with fourteen days' field punishment No. 2.

On 13 June 1916, John was arrested in Liverpool by Greater Manchester Police for being absent without leave. He was also charged with being drunk in Lord Nelson Street at 10.40 p.m., disobeying an officer and for being in Liverpool without a pass and given fourteen days' detention. John was then posted to Aintree Racecourse in Liverpool, maybe in the hope of changing his ways or maybe Knowsley had had enough of him. He was then charged with being asleep at his post at 4 a.m. on 13 July 1916 and awarded eighteen days' detention. Then, on 26 August 1916, he went absent without leave, before being apprehended by the Liverpool Police at 10.10 a.m. on 6 September 1916. John was given 168 hours detention and fined eleven days' pay. John was given seven days' confinement to barracks for going absent from 23 to 24 September 1916, then, amazingly, he was confined for three days extra on 26 September 1916 for shaving his upper lip (moustache) contrary to regulations, before being confined for another seven days on 17 November 1916 for absence from guard mounting parade. By 28 November 1916, the Manchester Regiment have had enough of John and he was transferred to the 6th Garrison Battalion Royal Welsh Fusiliers under the service number of 62569. He was still in Aintree when he was charged on 11 December 1916 with being in Liverpool without a pass, also added was a charge

dating back to 19 September 1916 for disobeying Mersey defence order No. 8. John is confined to barracks for seven days.

On 24 January 1917 he sailed from Devonport, arriving in Port Said, Egypt, on 23 February 1917. On 2 August 1917, John was transferred to The Loyal North Lancashire Regiment 2nd Battalion, service number 40187. He is charged on 7 September 1917 with having a dirty rifle on guard mounting parade, and given two extra guard duties. It looks like the Army was determined to change John, as his list of offences starts to get very petty; on 4 October 1917 he was given three days' confinement for having long hair, yet was awarded professional pay on 11 October. On 29 January 1918, he was awarded five days' confinement for eating the biscuits of his ration without permission, then four days' confinement on 7 February 1918 for being improperly dressed on 9.15 a.m. parade and not having his sheet rolled up. On 25 March 1918, he was given one days' confinement for having a dirty canteen on company parade. He left Egypt from Port Said on 18 May 1918, sailing to France and arriving in Marseilles. On 1 August 1918, John was killed in action; he was buried at Raperie British Cemetery, Villemontoire in France. He is remembered also on the war memorial at St Anthony's church, Scotland Road.

John Thomas Davies was born at No. 19 Railway Road Rock Ferry, Birkenhead, on 29 September 1895. His family later moved to St Helens, where John was employed at Ravenhead Brick and Pipe Works in Sutton. He was married to Beatrice and they had three children. During the First World War John was a corporal serving with the South Lancashire Regiment. On 24 March 1918 near Eppeville, France, his company was ordered to withdraw from action. He knew that the only line of withdrawal lay through a deep stream lined with a belt of barbed wire, and that to cross it the enemy needed to be held up. John jumped up on the parapet in full view of the enemy, in order to get a more effective line of fire, keeping his Lewis gun in action to the last, causing many enemy casualties and enabling part of his company to get across the river, which they would otherwise have been unable to do. John was believed to have been killed during this action and his parents were informed of his death. They were also told that he had been awarded the Victoria Cross. John had, however, been taken prisoner by the Germans and was being held in a camp at Zagan in Silesia, which is now Poland. A few months after his Victoria Cross award, his parents received a postcard telling them that he was alive. John is believed to be the only person ever to have been granted a posthumous Victoria Cross while still alive. He was wounded in action twice during the war, and both times recovered and returned to action. During the Second World War, John served as a captain in the home guard. He passed away in 1955 and was buried at St Helens Borough Cemetery.

John Carney 5083 enlisted with the East Yorkshire Regiment in 1895 and was appointed paid lance sergeant on 5 March 1914. He was a good football player and had the nickname Mick. He served in the 2nd Battalion during the Boer War and received the Queen's Medal with three clasps and the King's Medal with two clasps. During the First World War he served with the 2nd Battalion, losing his

John Carney.

right eye at Ypres in 1915. For that action he was awarded the Distinguished Conduct Medal. The *London Gazette* read, '5083 Sgt J. Carney DCM 26.7.17. For conspicuous gallantry and devotion to duty. He was largely responsible for silencing the enemy's snipers, and through-out set a magnificent example to those around him.' John was discharged to pension in 1915 with the rank of sergeant. Unfit for further service, he died in 1918 of pneumonia. Various family stories say he was gassed or contracted tuberculosis in the trenches, which made his lungs weak. It is possible, but it was probably Spanish flu. His death certificate says pneumonia and cardiac failure. John is buried at Ford Cemetery in Liverpool.

Richard Jones was born on 9 December 1887 in Liverpool. He worked as a shop errand boy and a bricklayer's labourer, before joining the Royal Marines Light Infantry (RMLI) in 1905. He served with them until August 1913 when he was discharged, but remained on the reserve list. He married Mary Connor in 1909 and the couple went on to have eight children. Richard was recalled back to training in July 1914, serving through the war until being demobilised in March 1919. While serving on HMS *Rinaldo,* he was part of the fleet that bombarded German forces in Belgium from the sea, his ship having been sent to protect the channel ports of Dunkirk and Nieuport, which were under threat from the German advance through France and Belgium. His brother John, who had emigrated to Australia, was killed in action while serving as Pte 6461 with the 7th Battalion Australian Imperial Force. Richard joined the Liverpool Police Fire Brigade in 1919, serving with them until 1948. In 1923, he was having a day out at Egremont Pier on the Wirral when he went to the rescue of three people who were drowning in the Mersey. He was awarded a medal for his actions. Richard passed away in December 1959 aged seventy-two and is buried at Ford Cemetery.

Frank Lester was born on 18 February 1896 in West View, Huyton, later living in Hoylake. He worked as a joiner and was a keen organ player before joining the South Lancashire Regiment on 30 March 1916. In June 1917, Frank was transferred to the Lancashire Fusiliers, becoming injured while serving with them on 21 March 1918, during the German spring offensive. After recovery in the UK, he returned to the front in September of the same year. On 12 October 1918, Frank, along with a small party of men, was sent in to clear the village of Neuvilly near Le Cateau. Frank was the first to enter a house using the back door, shooting two Germans fleeing by the front door. A moment later a fall of masonry from the upper floors blocked the door by which the party had entered. Their only way out now was through the front door into the street, but it was being was being swept by machine-gun fire at close range. Looking out, Frank noticed that an enemy sniper was causing many casualties to allied men who had occupied a house across the street. He shouted, 'I'll settle him', before running out into the street where he shot the sniper at close range and then fell fatally wounded; he was aged just twenty-two. Frank knew it was certain death to go out, but he gave his own life to save the men who were being picked off one by one; there is no braver act. Frank was buried at Neuvilly Communal Cemetery Extension in France. His colonel wrote to Frank's mother, saying, 'Your son's superb action is one of the bravest

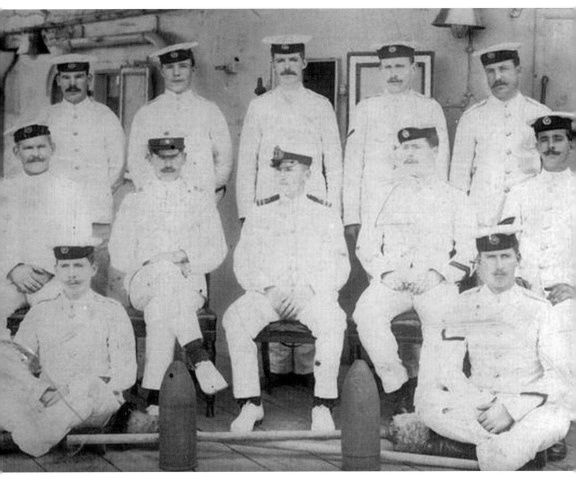

Richard Jones, second from left in rear row. Aboard the HMS *Cumberland* in 1909.

acts I can recall in this terrible war.' Frank Lester was posthumously awarded the Victoria Cross for his actions this day. Frank's brother Edwin was killed in action while serving with the 4th Cheshire Regiment in Palestine on 9 July 1917.

Just before Christmas 1915, a schoolboy at St Sylvesters Senior Boys' School in Sylvester Street, Liverpool, wrote a letter to a soldier serving with the Royal Army Medical Corps (RAMC). On it he drew a smoking soldier, a roast joint, a Christmas pudding and a packet of Woodbine cigarettes. The letter reads,

Dear Pte J. Furlong
I wish you a safe return. I want to tell you that we are all well, and I hope you are the same. Now that Xmas is drawing near I would like to wish you a Merry Xmas, and tell your chums I wish them the same. I am improving slowly, but surely in my work. I am not long in standard VI and I hope I will soon be in standard VII. I would like to hear you come home shouting 'we won the battle' I would like you to send me a spent

bullet or a badge in remembrance of you. I hope you will be home at Xmas and will come round to the school.

Wishing you a Merry Xmas and a bright and prosperous New Year.

I remain yours sincerely

Edward Cunningham

So who was Edward Cunningham? Standard V was for 10–11 year olds, so standard VI, mentioned in his letter, would have been for 11–12 year olds. From this, we have an idea of his age. An Edward Hugo Cunningham was born on the 5 December 1904 and was christened at St Sylvester's RC church on 11 December 1904. His parents were John Patrick Cunningham and Ann Bradley. The priest had added the information in the church records that Edward married Dorothy Maria McGuiness on 12 February 1936. Records show that Edward and Dorothy went on to have five children of their own. Edward lived at No. 24 Hopwood Street as a boy, which is very close to where the school stood. There is a death record in 1974 in Liverpool North for an Edward Hugh Cunningham with the same date of birth. Hugo is the Latinised form of Hugh. It would appear that Edward remained living within or close to the area.

But what about the soldier that he wrote to? Would it be possible to find out who he was? Young Edward was either just writing a school test to a made-up soldier, to someone on the Adopt a Soldier scheme, or he was writing to someone that he knew in some way. Local internet forums provide us with a number of people who still have letters and cards written by their parents or grandparents who also attended St Sylvester's school. The teachers wrote to them and the children copied them as a writing test. Nearly all of these cards tend to be addressed to 'Mum and Dad', 'Nanna and Grandad', etc., somebody that the child knew. This could be the case for Edward and he may well have known Pte J. Furlong and chose him for his writing test. Of course, he may well have been an imaginary soldier created just for the test, but he added drawings on the letter and put a lot into them, so it is probable that he knew this letter was going to be received by the soldier. There were a number of 'adopt a soldier and write to him' schemes during the First World War. Often these concentrated on soldiers who had no family and would therefore not get written to. There was one, for example, asking British women to write to Belgian soldiers whose families were in occupied Belgium and unable to write to them.

Did Edward know the soldier he was writing to? Was he a family member or friend, a man from his area, or an old boy of St Sylvester's school who had come along in uniform and impressed young Edward? If it was a local man that Edward was writing to then we do have one man that fits the bill and he lived right by Edward.

Patrick Joseph Furlong RAMC 61797 (91st Field Ambulance), who went to France on 23 November 1915, was a twenty-six-year-old distillery assistant. He lived at No. 14 Furlong Street, off Hopwood Street. He is listed as Patrick Joseph on his service details and Patrick on census returns, but his birth record shows he

was born Joseph Patrick Furlong. It was not strange then or now for people to use their middle names. He survived the war and lived until 1942. Is Patrick/Joseph the man who Edward wrote the Christmas letter to? We cannot be certain, but he ticks so many boxes, living almost in the same street as Edward, serving with the RAMC and being overseas at the time when the card was written. There is more than a fair chance that he is the correct man.

Daniel Fagan was born in Liverpool in 1892 to Peter Fagan and Elizabeth Welsh. He worked as a shop assistant in a grocery store before joining up for service. On 22 January 1916, Daniel married Christina Callaghan at St Joseph's church in Grosvenor Street. Within a year, their first child Elizabeth was born. Daniel survived the war and returned home to Liverpool, finding work as a timber carrier. The couple had two more children, Joseph and James, before Christina became pregnant with their fourth child in early 1926. As the year went on, Daniel's health began to deteriorate, stemming from a gas attack he had suffered while serving on the Western Front. On 29 October, their son was born and named after his gravely ill father, who must have cherished the few weeks he spent with his new son. On 12 December 1926, Daniel Fagan died at the family home in St Anne Street, aged thirty-two – the war had claimed another victim. You will find no entry for Daniel on memorials to the dead or within the CWGC records; his death, like many others, had come a few years too late for the record compilers. It is clear that Daniel died as a result of the poison affecting his lungs – the poison from the gas attack in the First World War. Daniel is buried in Ford Cemetery in Liverpool.

By the war's end, the fanfare and expectations of 1914 had disappeared, replaced by numbness, sorrow and disbelief. No brass bands and cheering crowds awaited the returning men. War has no victors, there was nothing to celebrate. The survivors came home in various states – injured, sick, shocked and mad, and the mental scars that many held would never leave them. The mourning began for the dead and memorials were erected all throughout the British Isles, cities, towns and villages – our dead would be remembered. In Prescot they had erected their main war memorial in September 1916; now in Merseyside more rose up to honour the fallen. As the years passed, a lot of the memorials were lost as buildings were demolished, firms moved premises, or simply by careless individuals throwing them out as rubbish. Thankfully, many still remain in the area today. It is impossible to give exact figures for casualties during the First World War. This was one of the bloodiest events in history, but estimates put the British deaths as over 700,000, with over one and a half million injured – a truly damning legacy.

THEY SAID I'D BE A HERO

They said I'd be a hero, the future would be mine
I thought I'll have a bit of that, tell me where I sign
Me mother cried, me sister cried, me nanna gave a frown
Dad gave me his best advice, yer head, yer keep it down

They sent me off a training, gave me my command
Scream and hold your rifle up, now go and stab the sand
Then off we went to help out France, and chase the nasty hun
They said it would be easy, they said it would be fun

The dead they were not laughing, nor those alive to tell
Nothing here was funny, but everything was hell
Then Jerry shouted over, Tommy be my friend
On this Christmas morning, let the fighting end

A wonderful conclusion, to all that had been pain
But the generals saw it different, so off we went again
They put me in a trench, somewhere on the Somme
With a silly looking helmet, to protect me from a bomb.

They said it was an order, that on the whistle blow
The Germans open fire, and I'm supposed to go.
I ask them were they joking, told them I aint daft
You have no choice they told me, coz we got your draft

Off we went a running, then jumped into a hole
Then we pegged it back again, I guess this was our goal.
Half of us got bollocked, by good old captain Fred
The other half lay wounded, crying, dying, dead

Off we went to Pash un dale, some place in Belgium
We hoped it was a holiday, a place to have some fun
They said we should be proud, we had served our country good
Then rewarded us with lice and rats, and stuck us in the mud

Off we went again once more, splashing up that hill
It went on 'til November, then it all went still
All throughout the winter, and right up to the spring
They had us marching everywhere, and made us bloody sing

Fritz he then came calling, and pushed us all right back
Then we pushed him back again, a bit off tit for tat

The Germans then got fed up, so everyone went home
The mothers got the telegrams, your boy is now just bone

They said we would be heroes, they'd cheer on our return
But we were cannon fodder, our purpose just to burn.
I got three shiny medals, for how I won the war
I took them home to Mary, then shoved them in a draw

As years pass by, my only wish, is people put away their fads
To remember all that happened, and those beautiful lost lads.

Anthony Hogan 2014

CHAPTER 2

LOCAL REGIMENTS

As the dark clouds of war gathered during the summer of 1914, preparations were being made by the British Armed Forces for enlistment, training and fighting. Liverpool was home to ten battalions of the Liverpool King's Regiment. At the outbreak of war they were stationed in the following locations: 1st Battalion in Aldershot arrived in France on 13 August 1914, 2nd Battalion in India (where they remained for the duration of the war), and 3rd Battalion in Seaforth, Liverpool, moved to Hightown after the outbreak of war. They were used as a training unit, spent the war in the UK and, in 1917, they were sent to Cork, Ireland. 4th Battalion in Seaforth, Liverpool, arrived in France on 6 March 1915.

The 5th Battalion of the King's Liverpool Regiment originated from the 1st Lancashire Rifle Volunteer Corps, which was formed in 1859. By 1908 it had become known as the 5th King's Liverpool. It was a very difficult battalion to join before the First World War; you would have needed an introduction from another serving member or a respected member of the community, such as a clergyman or police officer, who would then need to provide a reference of your character. The battalion headquarters was situated at No. 65 St Anne Street, where they recruited men from the north of the city. The battalion was know as The Rifles, but here confusion comes into it, as they were not officially a rifle battalion. They did, however, act like one, and wore their uniforms with blackened badges to indicate the rifles. The 6th King's, who were based at Princes Park Barracks, recruited their men from the south of the city and they were a rifle battalion. The 5th recruited from the north, acted like a rifle battalion, but were never given the title until 1924. The battalion moved to Canterbury to begin training for the front lines. In February 1915, they set off for Southampton. On 21 February, they boarded two ships, *Duchess of Argyle* and *Queen Empress*, before sailing for Le Havre, France.

At the outbreak of the Second World War, the battalion was based in the drill hall on Townsend Avenue. By 1943, the 5th King's had moved up to the West Coast of Scotland for training and they were being made ready for the invasion of France. They moved down to the south coast of England not long before June 1944 in readiness for the attack. At 3.30 a.m., on the morning of 6 June 1944, they sailed from Portsmouth aboard HMS *Cutlass*. Their job was to secure the

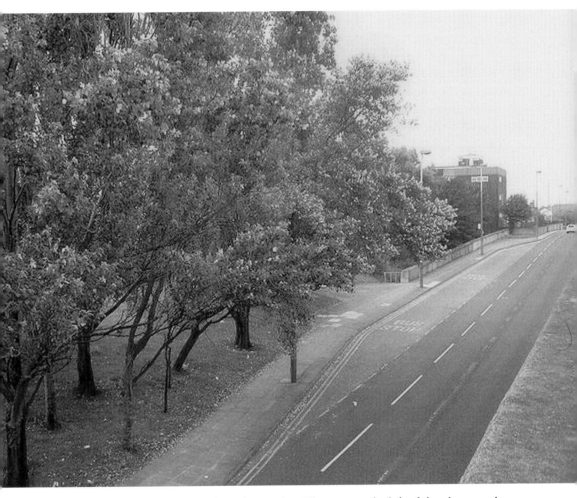

St Anne Street, looking towards the police station. The trees to the left of the photograph are where the 5th Battalion headquarters once stood.

landing area on Sword Beach. They were just over 2 miles from the French beach when they were transferred from the ship into landing craft. The 5th King's Liverpool became part of No. 2 T (Target) Force. They were used after D-Day to seize Nazi German scientists and businessmen, and to secure and exploit targets that could provide valuable military intelligence. In May 1945, they entered the German naval port of Kiel with the object of taking charge of the cruiser *Admiral Hipper*. They completed their mission, taking many prisoners; they also targeted the Walterwerke Factory, searching for and taking prisoner Dr Hellmuth Walter, the expert on hydrogen peroxide rocket engines.

The 6th King's Liverpool Battalion were based at Princess Park Barracks in Upper Warwick Street. They were formed in 1859 as the 5th Lancashire Rifle Volunteer Corps, and then named 5th Lancashire (The Liverpool Rifle Volunteer Brigade) Rifle Volunteer Corps in 1862. In 1881, they were allocated to the King's Liverpool

Regiment as the 2nd Volunteer Battalion, before the changes to the Territorial Forces in 1908 saw them become the King's Liverpool 6th (Rifle) Battalion. At the start of the First World War, the battalion was moved to Canterbury in Kent, before sailing for France in February 1915. In 1936, after Territorial Army changes, they became known as the 38th (the King's Regiment) Anti-Aircraft Battalion, serving with the Royal Engineers. In 1940, they transferred as a Searchlight Regiment to the Royal Artillery. They served at home in Liverpool and also in Derby during the 1940 Blitz.

The 7th King's Liverpool Regiment were based at No. 99 Park Street in Bootle. They had begun as the 15th Lancashire Rifle Volunteers in 1859, then, in 1880, they were renamed the 4th Volunteer Battalion, King's Liverpool Regiment. The territorial changes of 1908 saw them take the name of The 7th Battalion the King's Liverpool Regiment. They recruited men from the areas of Bootle, Litherland, Seaforth, Waterloo, Crosby and Southport, and had a volunteer company based on the Isle of Man. At the start of the war, the battalion was mobilised and moved to Canterbury in the autumn of 1914 for training. Before leaving, the 7th King's

Upper Warwick Street. Princess Park Barracks stood on the site of this building.

marched to Bootle Town Hall and lodged their Colours with the Lord Mayor of Bootle. As well as training in Canterbury, they also spent time in Southampton guarding the docks and railways. They left the UK for France and arrived at Le Harve on 8 March 1915. In 1938, the 7th King's Liverpool Regiment joined the Royal Tank Corps as the 40th King's Liverpool Regiment. They still took their recruitment from the same areas as they always had done. During the Second World War they served in North Africa, fighting at El Alamein, where they gained the nickname 'Monty's Foxhounds'. They saw action in Egypt, Libya and Tunisia, before moving into Italy, then Greece.

Liverpool's large Irish community first formed a volunteer battalion due to tension with France. The roots of the regiment go back to an advert in the *Liverpool Echo* in December 1859, calling for Irishmen to rally for the defence of Britain. By 1864, they had been designated into the 64th Lancashire Rifle Volunteer Corps, one of a number of volunteer corps that was raised due to heightened tension with the French. Strongly proud, their Irish heritage became part of their traditions and uniform, once wearing a uniform very similar to the Royal Irish Rifles. The Liverpool Irish eventually wore the caubeen headdress with red and blue hackle; they added pipers and included the saffron kilt and shawl. While the battalion was strongly proud of its Irish identity, some people associated Irish status with indiscipline and disobedience, which is what the Liverpool Irish were to gain a reputation for. Some people fearing volunteers from Irish descent had insisted they had joined the 64th only with the intent of learning and perfecting themselves in the use of arms, claiming that their new skills could then be used for their opposition against home rule. A number of nationalist organisations based in Liverpool had discouraged prospective volunteers and condemned those who joined the corps.

The Liverpool Irish became the 5th (Irish) Volunteer Battalion of the King's Liverpool Regiment. They sent 224 volunteers for service in South Africa (Second Boer War), having fought at Belfast, Bethlehem, Klip Flat Drift, Lydenburg, Sand River Draft and Slabbert's Nek. They returned to Liverpool in November 1900 and marched to St George's Hall, where they were greeted by the Lord Mayor and their relatives. In 1908, their Volunteer Force status was changed to Territorial Force and they were renumbered the 8th King's Liverpool Regiment. Before 1908 they had maintained a Bicycle and Mounted Infantry Company. In 1910, the numbers based in the headquarters at No. 75 Shaw Street, Liverpool, numbered 942 and the commanding officer was listed as Col J. A. Cooney. At the start of the First World War the battalion was mobilised and sent to Canterbury, Kent. After training they sailed to France, arriving in Boulogne on 3 May 1915.

The 8th (Irish) King's Liverpool Battalion was disembodied on 14 June 1919 and disbanded on 31 March 1922. In March 1939, with war looming, they reformed with their headquarters at The Embassy Rooms, Mount Pleasant, Liverpool (The Irish Centre). Recruitment began in May 1939. After training, the battalion was given duties across Britain, first in Morecambe and Yorkshire. As the Allied plans to invade occupied France developed in 1943, the Liverpool Irish were chosen to form the nucleus of the 7th Beach Group. The group's objectives during an

Shaw Street/William Henry Street. The grassed area was the site of the 8th headquarters.

invasion of France were to maintain organisation, secure positions and provide defence against counter-attack. The Liverpool Irish undertook specialist training in Ayrshire as they prepared for D-Day. By 1922, the headquarters at No. 75 Shaw Street was occupied by 106th (Lancashire Yeomanry) Field Brigade, Royal Artillery, 423rd (Lancashire Hussars Yeomanry) and 424th (Lancashire Hussars Yeomanry) (Howitzer) Field Batteries, Royal Artillery. In 1938 they became part of The Royal Horse Artillery, and in the Second World War, they served in Palestine and Egypt.

The 9th Battalion had been formed in 1859. On 21 February 1861, they became 80th Lancashire Rifle Volunteers, before changing again on 2 April 1863 to the 73rd Battalion of the Lancashire Rifle Volunteers. In 1888, they were renamed the 6th Volunteer Battalion of the King's Liverpool Regiment. Early meetings and parades took place at Rose Hill Police Station or at the Corn Exchange in Brunswick Street, before they set up a headquarters at No. 16 Soho Street. In 1884,

they moved once more, this time to No. 59 Everton Road, where the battalion remained until 1914. In 1908, they became the 9th Battalion of the King's Liverpool Regiment Territorial Force. They arrived in France in March 1915. The battalion saw action in France and Belgium, fighting at Aubers Ridge, Loos, the Somme, Ypres, Cambrai and Arras. During Army changes in the 1920s, the 9th King's Liverpool Regiment became part of the Royal Engineers.

The front of Shaw Street HQ has been boarded up and unused for a long time, but the drill hall buildings at the rear have been used by the Red Triangle Karate Club for the best part of thirty years. It is to their credit that they have preserved the original fixtures in the old drill hall. If it had remained empty and unused, I dread to think of the condition it would now be in.

The 10th (Scots) King's Liverpool Battalion began on 30th April 1900, when, due to the Boer War, it became clear there was a need for men to volunteer their service. It was raised from the higher educated and professional young Scotsmen of

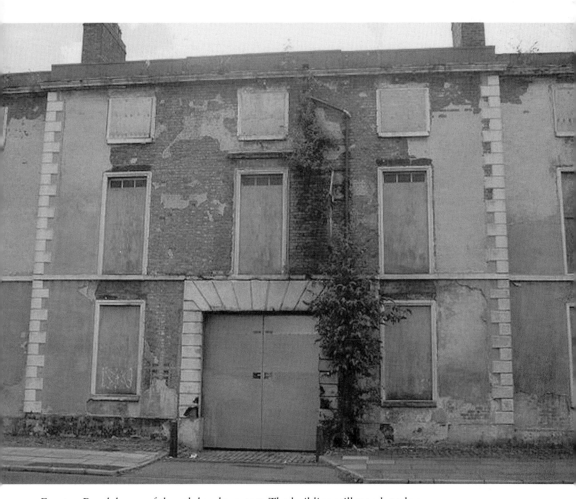

Everton Road, home of the 9th headquarters. The building still stands today.

The drill hall with it original floor, preserved along with a number of the hall's features.

the city of Liverpool, and named the 8th (Scottish) Volunteer Battalion, the King's Liverpool Regiment. To join, you paid an annual subscription of 10s and an entrance fee of £2. The first commanding officer was Col C. Forbes Bell. They set up at No. 22 Highgate Street, Edge Hill in Liverpool. Through subscription in 1904, they found a home for their headquarters and drill hall at No. 7 Fraser Street. In 1901 they were allowed to wear the Highland dress, choosing the Forbes tartan in honour of their commanding officer. Twenty-two of the men served in South Africa (Boer War). By 1908, their title was changed to the 10th (Scottish) Battalion The King's Liverpool Regiment, Territorial Force. They became one of the first infantry TA battalions to join the British Expeditionary Force when the call came for them to enter war service in August 1914. In September 1914 they were training in Fife, Scotland, and, by October, the Liverpool Scottish were camped at Tunbridge Wells in Kent, before moving to Southampton where they boarded the SS *Maiden* and sailed for France on 1 November 1914, sharing the journey with the Queen's Westminster Rifles.

Fraser Street. The car park once housed the 10th headquarters. The building later became the nightclub Pickwicks.

1920 saw the Territorial Army reformed. The Liverpool Scottish formed a friendship with the Queen's Own Cameron Highlanders and, in 1937, they transferred to them, thus becoming the regiment's second territorial battalion. Number designation was not included, but the battalion's identity was preserved and they remained at their headquarters in Fraser Street, Liverpool. In 1938 King George VI presented the battalion with new colours at Everton's Goodison Park Stadium. With the threat of the Second World War, the Liverpool Scottish were allowed to form a second battalion and they were mobilised for war service, although they were informed that they would remain in Britain. Some of the men serving with the battalion did manage to serve overseas, as drafts were provided to a number of regiments – mainly the Cameron Highlanders. They also provided men for the Independent Companies – these would later become the Army Commandos.

The Grange on Edge Lane is listed in an 1891 record. Also mentioned is that it had an ornamental garden where the older part of the TA Centre now stands. The 1900 Gore's directory lists it as '4th L.V.A.(Position Artillery). Headquarters, The Grange, Edge lane.' A record shows that the old Grange was taken into use in 1900; the original building was an old sandstone farmhouse to which was added a large covered drill shed. A 1908 Ordnance Survey map shows a drill hall detached behind The Grange. During the First World War it housed the '4th West Lancashire Howitzer Brigade, RFA, TF', who became 276th Brigade Royal Field Artillery in the latter part of the war when many units were renumbered. They suffered several changes in title over later years, but always had '4th West Lancs' somewhere in their name. They had previously been part of the Royal Garrison Artillery. A 1937 TA recruitment poster lists 59th (4th W. Lancs.) Med. Bde. R.A. Edge Lane, Liverpool 7.

A 1905 map shows Windsor Barracks standing on Spekeland Street, between Overbury Street and Chatsworth Street. In 1881, the 2nd Lancashire Artillery

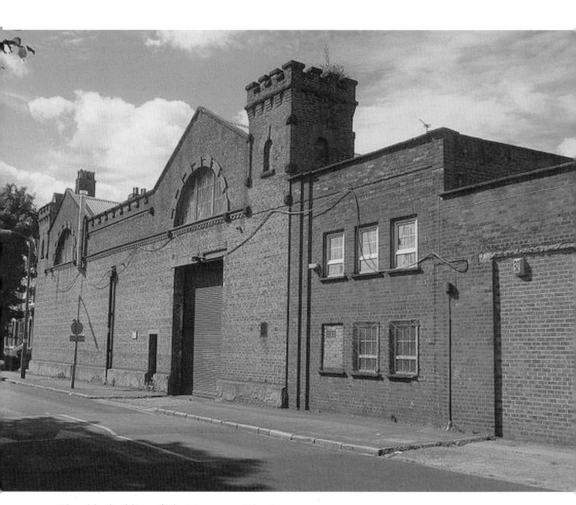

The older building of The Grange on Edge Lane.

Volunteers were listed at Windsor Barracks, Spekeland Street. In 1908, the corps became part of the 1st West Lancashire Brigade RFA of the newly formed Territorial Force. In 1914, The 1st West Lancs Brigade RFA were still listed here. As war broke out they recruited and formed a second line, so the two lines became 1st/1st and 2nd/1st. In 1916 all units were renamed, with 1/1 becoming 275th Brigade RFA (TF) and 2/1 the 285th Brigade RFA (TF). On 7 August 1915, officers and men from the 1st West Lancs Brigade spent an afternoon at Betteshanger Park in Kent playing sports. So we can assume that they were in Kent training for war. They served on the Western Front during the First World War.

On Wellington Road in Wavertree stands a rather splendid looking building that is now owned by the Frontline church. It has a date stone of 1914 and a marker stone with the initials RGA (Royal Garrison Artillery). Was it being built for the RGA when the First World War broke out? We know that the 87th 1st West Lancashire Field Ambulance, Royal Army Medical Corps (RAMC) were here in 1914 (they were a territorial Battalion who serve in Gallipoli and on the Western Front). A mention is made of a First World War hospital on Wellington Road in Liverpool; it is probable that it was housed within this same building.

The 4th Cheshire Regiment, Welsh Division had their headquarters in Grange Road West, Birkenhead, and Urmson Road, Wallasey. At the start of the First World War, they were mobilised and moved to Shrewsbury, Church Stretton, and on to Northampton. By Christmas 1914 they were in Cambridge. Early in 1915 they were again on the move, this time to Bedford, before sailing in July 1915 to Alexandria in Egypt, then on to Gallipoli, Turkey, where they arrived on 15 August. In December 1915, they returned to Alexandria, remaining there until sailing to France on 31 March 1918.

In November 1914, recruitment started in Birkenhead Town Hall for one of the most unique Pals battalions, which went by the name of 'The Birkenhead Bantams'. What made them different was that they had been set up to take those men who were under the height of 5 foot 3 inches and therefore unable to join the Army due to height restrictions. Men came to Birkenhead from all over the country to join the battalion that would allow them to serve and fight, their average height being just 5 feet. Within days they had enough men to form two battalions who would become the 15th and 16th Cheshire Regiments. The men trained at battalion headquarters that had been located at Bebington showground. They sailed for France at the end of January 1916 and saw action at the Somme, Arras and Passchendaele. Sadly they took many casualties during their actions. They were disbanded in 1919.

The Cheshire Field Company Royal Engineers had their headquarters at No. 79a Harrowby Road in Birkenhead. They served in France and Belgium during the war, seeing action at Ypres and the Somme, as well as being involved in the battles of Hooge, Cambrai, Albert, Arleux and Longueval, to name just a few. The 13th (Wirral) Cheshire Battalion was formed mainly of workers from the Port Sunlight Soap Factory. They saw action on the Western Front.

The local directories for 1908 gives a listing for a headquarters and one battery of The 3rd West Lancashire Brigade, Royal Field Artillery TF, at Admiral Street in

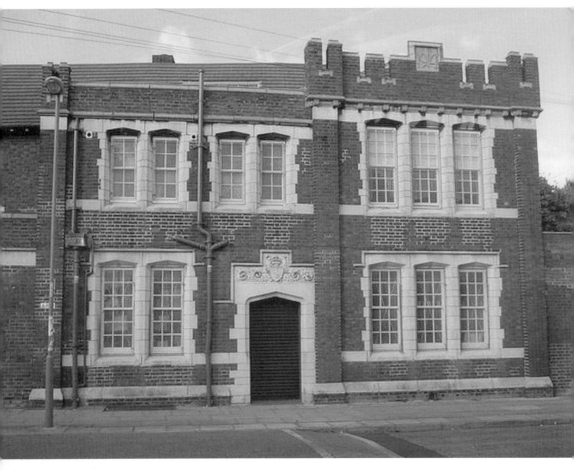

The barracks on Wellington Road.

Liverpool. In 1912, The 12th Lancashire Battery is listed here. The 13th Battery were based at No. 1 Earp Street in Garston. In 1916, the Army renumbered the unit as 277th Brigade. A memorial plaque in the Garston British Legion Club remembers the members of the 13th Battery, who gave their lives during the First World War.

Seaforth Barracks on Rawson Road opened in 1882. Built as a cavalry barracks, it housed men and horses. It later became a base depot for the Royal Garrison Artillery and Royal Field Artillery; men from the barracks would help to man Seaforth Battery that stood on the opposite side of the River Mersey to Fort Perch Rock in New Brighton. The 3rd and 4th Battalions of the King's Liverpool Regiment were based here at the start of the First World War. The barracks was a major recruiting centre for men from the north of Liverpool; many men signed up here during the First World War. In the Second World War, a lot of American servicemen were based here before leaving for D-Day training.

What remains of the house of Joseph Williamson, the mole of Edge Hill. Joseph was an eccentric businessman, property owner and philanthropist who moved into

this house in Mason Street in 1805. He is best known for the tunnels that he built underneath Edge Hill. Believed to be built to keep men in work and out of poverty, they consist of underground halls and brick-arched tunnels. This house and the area around it became a Military Volunteer headquarters, housing numerous units. Across the road from this building was another military building that housed a volunteer drill hall, parade ground and armoury. It backed onto Highgate Street, where another volunteer drill hall stood at No. 22, sharing the parade ground. This part of the house has survived due to its connection with Joseph Williamson; it stands not only as a reminder to him, but also to the many servicemen who attended here over many years. The buildings in this area were used by the military during both world wars.

Joseph Williamson House.

CHAPTER 3

ANTI-GERMAN RIOTS

For the German people living in Britain, it must have been a worrying time when the First World War became a reality. As the war began, a few incidents of violence and protests against the German members of the population rose up, though many were able to carry on with their daily lives as best they could. A number of sanctions were imposed and they were always under the watchful eye of the authorities. Most German-born people were removed from any government office jobs they held, and a number of businesses removed their German employees. They were asked not to use certain shops, restaurants and public buildings. Internment on the Isle of Man was the outcome for some.

In Liverpool, the German residents saw little opposition to them in the early months of the war and, although certain sanctions had been put in place, those not interned could go about their daily lives as normal. They had become part of the local communities, living and working here for many years, marrying into English families. Most of the Pork Butchers and Shoe Makers in Liverpool were German-run; they had also set up the German Evangelical church, along with the Deutscher Klub and Deutscher Liederkranz (a singing society). They were well respected in Liverpool. On 7 May 1915, all this was to change with the sinking of the RMS *Lusitania*.

The sinking of the *Lusitania* was a major event of the First World War. Many believe it was the first in a series of events that would lead to the Americans joining the war. *Lusitania* is regarded as the second most famous ship to be lost at sea after the *Titanic*. Much has been written about her sinking on 7 May 1915 off the coast of Ireland, when the German submarine U-20 fired a torpedo into her Hull. She sank within eighteen minutes, the loss of life was of a terrible scale: 1,198 people died (785 passengers and 413 crew). Many of the crew were from Liverpool, the majority from the close knit Liverpool Irish communities in the north end of the city. For them, it was total devastation with so many of their men lost. Our Lady of Reconciliation church in Eldon Street has a First World War memorial that names ten men who died in the sinking of *Lusitania*. A further ten men from the nearby area also perished – twenty men in total from a few streets. This was the story throughout much of the north end of Liverpool. Reports suggest that the first signs of trouble came from family and friends of the dead

sailors. Riots then broke out across Liverpool, spreading not just through Britain, but to other cities across the world. Such was the impact of *Lusitania*.

The north end of Liverpool saw the first signs of violence on Saturday 8 May, when attacks took place at Mr Fischer's store on Walton Lane. The shop windows were smashed and food was thrown into the street. Dimler's store on County Road was also attacked. The police arrived and struggled to gain control before forcing the crowd into Spellow Station on County Road, where they ransacked three more shops. Around sixty officers tried to clear the crowd, which had now risen in size. As it was moved, the crowd targeted Deeg's shop on Fountains Road, pulling the shutters from the shop and throwing them into the road before destroying the front of the store. On Robson Street, a pork butcher's shop was attacked and nineteen people were arrested. Calm was restored, with no more major incidents reported. The disturbances continued into Sunday 9 May when Dimler's on County Road was again set up. Fox Street, Juvenal Street, Mile End, Heyworth Street and Richmond Row all saw violence as businesses were attacked. A pork butcher's shop on Scotland Road was vandalised and completely looted of all its contents. Public houses across Liverpool were ordered to close their doors by 6 p.m., while Wallasey made its pubs close by 2 p.m. By the end of the weekend the police had made sixty-seven arrests, with most of the trouble occurring in the north end of Liverpool, though smaller incidents were reported across the city.

By Monday 10 May, the violence had grown to a serious level across the city, as men, women and children were reported as taking part in the attacks. German pork butcher's shops had been the target over the weekend, but now any butcher's shop was being hit, along with any shop that was or appeared to be run by German people. The north end of Liverpool again saw trouble as Deeg's on Fountains Road was again set upon, and lost what remained of its windows. The trouble moved to the south end of Liverpool, where a crowd estimated at over 2,000 made for the pork shops along Mill Street, Northumberland Street, Windsor Street, North Hill Street, Upper Hill Street, Warwick Street, St James Street, Lodge Lane and Crown Street. Police had been posted on guard outside many shops, but they had little chance of stopping the huge crowd, who smashed windows and looted the contents of the stores. Violence flared in Paddington, while Yaag's Butchers on Great George Street was set upon. The trouble spread to Bootle, Birkenhead and Seacombe. A fountain pen factory at Seacombe came under attack, as it was believed a German was running it. The police struggled with the crowd, who had come to attack the premises, but eventually they regained order, though not before much damage was done. A pork shop in Birkenhead was ransacked and the furniture from the home above the store was thrown into the street and set on fire.

The police were using all their resources, with special constables being transported around to the worst trouble-hit areas. They were using everything they had and, although some reports suggest that at first they were turning a blind eye to attacks on German-run shops, it does seem that in fact they were trying to do all that they could to stem the violence. They were at their limit, and during the day, the chief constable of Liverpool had been in contact with the Home Office, with a request

for help from the military. This was granted, but the troops never came onto the streets. The sixty-seven people who were arrested over the weekend appeared at the Magistrates Court in Dale Street, with those found guilty being remanded for seven days. The judge said that although he could understand that the first news of the *Lusitania* sinking affected everybody, he rejected it as a justification of the riots. He also warned that future rioters would be dealt with in a much more harsh manner.

The attacks, although starting to ease off, were still taking place on Tuesday 11 May. A crowd tried to march in the suburbs of Wallasey, but were stopped and turned back by a police cordon at Wexford Road. After Liverpool, the riots spread to Manchester, then to many other parts of Britain. Forty-five more people came before the judge at Dale Street, and he carried out his threat from the previous day by jailing the guilty to between twenty-one to twenty-eight days. He also noted the number of men who appeared to be of military age, and suggested that if they wanted to fight the Germans then they should do it in a military uniform. Other courts across the city also dealt with the rioters and those found guilty were given custodial sentences. A lot of people who came before the magistrates had claimed they had acted in revenge of their own people aboard *Lusitania*. She was a registered Liverpool ship and they considered her one of their own, affectionately calling her 'Our Lucy', though none of those charged had a relative serving on the ship. One man who was brought before the judge at Dale Street said that he had served aboard *Lusitania* a few months earlier and was acting in revenge towards the sinking of his ship. It was proved that he had never served aboard the ship and was using the sinking as a lame mask against his crimes. Attacks on German and other foreign people would not be tolerated by the courts. One man, who had thrown a stone into a Scandinavian shop, was ordered to pay compensation of 30s and called a coward. A woman was imprisoned for twenty-eight days for being drunk and violent, and received another fifty-eight days for breaking the windows of a Russian-run shop.

The *Liverpool Courier* described the events in a rather emotive fashion on 11 May:

> The disaster to the Lusitania, in which helpless non-combatants were foully murdered, has affected Liverpool in particular. By one coward blow hundreds of homes in the city have been bereft. Can there be any wonder that among the less disciplined classes, who have had to freely sacrifice their menfolk on the battlefield, the feeling of bitter enmity against the Germans should be exacerbated beyond restraint? From the streets wherein dwelt the sailors and firemen who were murdered by the Germans who torpedoed the Lusitania have gone crowds of people who, in their passionate resentment against all things teutonic, have not been able to distinguish between friends and foe.

It is worth noting that as the riots in Liverpool carried on, the anger of the crowds turned from just being anti-German to anti-alien. Scandinavian, Italian, Chinese and Russian businesses were targeted; after the shops, they attacked homes. Throughout all of this, there is evidence that people were still willing to help

and protect members of their communities who had fallen victim to the anger of the crowds. At the start of the First World War, seventy-five per cent of the pork butcher's shops in Liverpool were run by German families; at the end of the war it was believed that there were no German butchers remaining. Many had been rounded up along with other Germans working and living here, and sent to camps on the Isle of Man. Later, many were returned to Germany. Others we know were helped by friends from the communities that they had become such a part of. One man of German birth who had had his store damaged presented himself at a city centre insurance firm to seek compensation. As he was about to enter the insurance building, a woman recognised him and shouted to onlookers that he was a German; the man had to hide inside the building while the police guarded the doors and dispersed the crowd who had gathered. The Dimler family, who ran a number of pork butcher's shops in the Liverpool area, had two sons, George and Charles, serving in the British Army during the First World War. After the war, they managed to re-open one of their butcher's shops on Stanley Road near Marsh Lane, but renamed the shop Allenby's, using the surname of the hero of the Middle East/Palestine campaign, General Allenby. The shop, with that name, managed to survive as a pork butcher's into the middle of the 1970s.

After a couple of days of riots in Liverpool, anyone German was rounded up for internment – many for their own safety. Homes began receiving early morning calls as people were taken away, often in handcuffs. At first, most were housed in the main bridewell, but it became overcrowded very quickly. It was then decided that everyone would move to a camp at Hawick in Scotland. Trains were laid on at Lime Street Station and, although large crowds had gathered to watch them depart, no anger was directed towards them. Often, the authorities who called looking for young men of German birth were greeting them with the phrase, 'He is serving in the British Army.' Many men were serving in the Army; having changed their German surnames to something more British, their loyalty to Britain can never be questioned. In the Second World War, similar stories would unfold as the authorities searched for young Italian men, only to find again that they were serving for the British Forces. The Isle of Man housed two internment camps during the First World War, at Douglas and Knockaloe near Peel. The Douglas Camp was a former holiday camp, while Knockaloe had been purpose-built using prefabricated huts, and even had its own railway link. They held a large number of Germans over a five-year period, before the camps finally closed in 1919. A lot of the Liverpool Germans would have been held on the Isle of Man, where over 200 of the interned died. Many of the men held were married to British women, and this caused them much worry as to how their families would survive with the breadwinner taken away. After the war, many were returned to Germany and had to fight to get back to Britain – a few never made it back. This was a rather harsh way to treat them when the war was done, as their homes were in Britain after all.

The 1910 Gore's directory has Charles C. Bobbie listed as the licensee of the Britannia Hotel at No. 283 Breck Road, Liverpool. Census returns show he was born Charles Claus Bobbe in 1868 in Liverpool. His parents were Christopher

and Mary Bobbe, both from Germany. Charles grew up in the Scotland Road area of Liverpool and ran a pub on Great Homer Street before moving to Anfield. He married Margaretha Dorathea Schumacher in Liverpool in 1891. Dora, as she was known, was born in Germany. They stayed in the area until their deaths (Charles in 1933 and Dora in 1927). In 1918, their son Christopher Frederick was serving with the British Army as rifleman 376063, with the London Regiment (Post Office Rifles). As the war drew to its end, Christopher found himself on the Somme region of northern France. Sadly, while fighting here with his regiment, on 28 June 1918, Christopher was killed in action. He was just eighteen years old. Christopher is buried at Franvillers Communal Cemetery Extension. In 1915, Charles and Dora had witnessed the smashing of their public house on Breck Road

This building was the Britannia Hotel, No. 283 Breck Road, at the corner of Coniston Street. Charles Bobbie was the licensee here.

during the anti-German riots. In 1918, they received the dreadful news that their son had died while fighting for the British Army against the German Army.

On the same block three doors away at No. 277 Breck Road was Conrad's pork butcher's shop, run by George Conrad. This was also raided in the attack. Local man Charles William Hogg, who was eighteen at the time, remembered the 1915 May riots stemming from the sinking of the *Lusitania*. He witnessed the attack on the Conrad Premises at No. 277 Breck Road and how a grand piano was pushed out of an upstairs window. Nearly all the German pork butcher's were attacked, and also Germans following other trades like Charles Bobbe and his family, who were Pub licensees at the Britannia Hotel. At this time, Charles Hogg's Grandmother took the Bobbe children to stay in their home.

A pork butcher's shop on the corner of Smithdown Road and Arundel Avenue was attacked during the riots. Every window in the shop had been broken and most of the stock was looted. It was reported that two women had been seen laughing and throwing strings of sausages to each other, while another pretended to scrub the floor with a pork joint. Once the shop had been ransacked, the mob made their way upstairs, intent on destroying the family home. The piano was hurled through a window onto the street below, before a man appeared at the open window holding a huge mirror above his head. He smashed it across the stone sill to loud cheers from the crowd below. It is believed that the family from the pork shop had hid in their wardrobe to protect themselves. In 1906 and 1911, a Henry Rutsch is listed as operating a pork butcher's shop from these premises. In 1916, he is listed at the address, so it was he and his family that came under attack during the riot. How much did it affect him? The *London Gazette*, dated 11 of February 1916, listed the following,

> Henry Rudge, heretofore and known by the name of Henry Rutsch, of 142 Smithdown Road, Liverpool, Pork Butcher, herby give public notice. that on the 19th day of January 1916, I formally and absolutely renounced, relinquished and abandoned the use of my said surname RUTSCH and then assumed and adopted and thenceforth on all occasions whatsoever to use and subscribe the name Henry Rudge instead.

In the 1911 census, Henry is listed as a pork butcher living with his family at No. 142 Smithdown Road. The building is described as having ten rooms. Henry had been born in Germany in 1867. In 1902 he married Bertha Baier in Liverpool. Bertha had been born in Liverpool in 1869 to German parents; her mother Katherine was living with the family at Smithdown Road in 1911 aged sixty-five.

The two Liver Building birds that sit watching over the city, river and the sea, were designed by a German sculptor Carl Bernard Bartels. Carl was brought up in the German Black Forest, later moving to England in 1877, where he took British nationality. Carl Bartels entered and won a competition with his Liver bird design, the end product being two 18-foot high copper sculptures that were erected in 1911. When the First World War broke out, Bartels was arrested as a German and imprisoned on the Isle of Man. After the war and despite being a British citizen

No. 142 Smithdown Road, with the corner of Arundel Avenue. Scene of an attack during the riots.

with a wife in London, he was sent to Germany. It took him many years to be able to return to England, where he lived until his death in 1955. During the Second World War, Carl had used his skills to produce artificial limbs for wounded British servicemen. The city of Liverpool removed all references of his achievement from the record books. It would appear that they did not want it known that the Liver bird, one of Liverpool's proudest and most iconic symbols, had been created by a German. It would take the city over ninety years to return recognition to Carl and give him the credit that he deserved.

Lord Derby had suggested during the Liverpool riots that, as so many people wanted to avenge the *Lusitania* and fight the Germans, that a Lusitania Battalion could be formed if enough volunteers came forward. The battalion could then be used to support the King's Liverpool Regiment. The Lusitania Battalion never

happened. Suspicion fell upon the British monarchy and King George V was persuaded to change his German name of Saxe-Coburg and Gotha to Windsor, and relinquish all German titles and styles on behalf of his relatives, who were British subjects. The German Shepherd breed of dog was renamed to the euphemistic 'Alsatian'; the English Kennel Club only re-authorised the use of 'German Shepherd' as an official name in 1977 – it is almost laughable.

CHAPTER 4

BERNARD MCGEEHAN

One of the biggest injustices of the First World War was the execution of soldiers who were shot at dawn for cowardice. In 2006, the British Government quite rightly pardoned 306 men who were executed by the British Army, although it remains a shame that it took the best part of ninety years for this to happen. These men are now officially honoured by the British Government, along with their comrades who died during the First World War. Most of us, however, have always honoured them and knew them as the brave heroes that they were. We have to remember that things happened a long time ago and that it was a far different world to the one we now live in. It is very upsetting to read about these events, but read them and remember we must.

Twenty minutes – yes, most court martial hearings lasted no longer than twenty minutes – it took just twenty minutes to decide a man's fate, once decided there was to be no appeal. During the hearing, the man was often not allowed any legal representative; medical evidence proving some men were suffering from shell shock was often not submitted to the courts, if it was, then it tended to be ignored. Basically, an unfair trial sent these men to their deaths with their execution often being carried out by their own comrades. The British government tried to keep it secret, but word spread about what was happening and, as it did, the question was brought up in the House of Commons. It was denied, they were lying, they knew.

Many people believe these men were executed to frighten other men into doing what they were told, intimidating them back into the trenches or scaring them into going over the top during an attack. Making an example of the executed men was a way of keeping others in line. Consider if you will a British Tommy in the trenches – he is wet, cold, scared, under fire from shelling and sniping, he lacks sleep. He is always ready for the enemy attack, he is expected to carry out an order without question, he is on edge, he may be young. He does not want to die. He climbs out of a trench to attack, he faces machine guns, exploding shells, barbed wire, bayonets, noise. He hears the injured screaming, he sees his friends die, he bears witness to unimaginable horrors. In battle he is confused, often alone, as his comrades have been killed. He hides like a rat in a shell hole; only the dead are his company. He waits until dark before he can crawl back to his lines, always

expecting that bullet or shrapnel to get him. He does this over and over again, in the trench, out of the trench. His nerves are hard to control, he is a changed man. If he loses his way in battle, if he shakes and cannot move during an attack, if he loses his weapon. . . So many ifs, but just one can label him a coward and he can be shot for an if. All of those pardoned remain not forgotten and remembered for the brave men that they were.

Bernard McGeehan was born in 1888 in Raphoe, County Donegal, Ireland. His parents later moved to Moat Street in Derry, where Bernard, his brother Neil and sister Nellie would settle. He did not do well at school and was thought of as not very bright; he later found work as a messenger boy for the Post Office in Derry before going on to work with his father, who ran a business buying and selling horses in Ireland and England. He fitted in well with the horses. He had an obvious talent as a groom and preferred to be in the background sharing their company. The family later moved to Dublin. Today, Bernard would come into the category of special needs; it is clear he had a form of autism.

On 11 November 1914, Bernard joined the 1/8th (Irish) King's Liverpool Regiment as Pte 2974. He signed up in Liverpool and gave his address as No. 10 Daulby Street, Liverpool (next to the Royal Liverpool Hospital). This address is listed as Waites Boarding House, so it must be the digs he took when he came over from Ireland to enlist. Bernard would have spent time at the 8th's regimental base, which was a short walk away in nearby Shaw Street. Records show him as being 5 foot 5 and 1/2 inches tall, weighing 147 pounds, with a chest measurement of 34 and 1/2 inches. His physical development is good, eyesight good, but his teeth are very bad; he gives his occupation as a groom. His next of kin is given as his father, Bernard McGeehan of No. 7 Annesley Place, North Strand, Dublin. His mother was listed as having passed away on his enlistment papers.

Bernard trained in the UK, with his regiment being mobilised in Canterbury, Kent. After training, they sailed to France, arriving in Boulogne on 3 May 1915. By 16 June they were seeing their first action at Artois in the Givenchy region of France; they suffered large losses here. A few weeks later, on 14 July, Bernard was charged with being absent from duty and given three days field punishment No. 2. This entailed Bernard being kept in shackles and being made to do to hard labour. Bernard's time in the Army makes for unhappy reading; he struggled to understand orders, sounds of machine gun and artillery fire would play on his nerves and he was also being bullied by his fellow soldiers, who ridiculed him and played cruel tricks on him to make him believe that he was under attack. Senior ranks and officers looked on Bernard as being a bit thick and useless as a soldier.

On 31 March 1916, Bernard was awarded fourteen days' field punishment No. 1 after being found guilty of neglecting to obey an order, and for losing government (Army) property by neglect. The offence had happened on 24 March. He was also informed that he was to repay the cost of the lost property from his wages. Field punishment No. 1 was more severe than No. 2; it would see the man tied to a gun wheel or some other object in full view of other soldiers. The man would remain in this condition for up to 2 hours in a 24-hour period – often the man would be

unable to move at all, having been tied so tight. The soldiers called this punishment 'crucifixion' and, due to the humiliation it caused, they considered it to be unfair.

On 4 May 1916, Bernard was sent to work in the store yard refilling points. This order kept him out of the front lines, however, the huge losses suffered in the early days of the battle of the Somme meant that he had to return to his regiment as they entered the trenches on 20 July 1916 at Guillemont. On 8 August they attacked and pushed through the German front lines, but they had advanced so rapidly that their support was unable to keep up. Now surrounded, they had to hold out as best they could, suffering many losses in the process with a number of men taken prisoner. They stayed on the Somme for the next two months, in and out of action facing daily danger. On 20 September, as his regiment was about to enter the battle at Deaths Valley, Bernard slipped away and decided to go for a walk. It appears that he had finally cracked with the stress; he was shell shocked, shaking, bewildered and lost. When he tried to return to his unit he could not find them. For the next five days he walked around looking for them, then, on 25 September, he approached another British unit and asked for food and directions back to his regiment.

The unit he had asked were in Montreuil – this is 40–50 miles from where he had been, it shows how far he had walked. His own regiment had moved on into Belgium and, by 28 September, they were at Brandhoek in between Ypres and Poperinghe. Bernard was escorted to his regiment in Belgium; once there, he was court-martialled on a charge of desertion and placed in confinement awaiting trial. The court offered no help to Bernard when they failed to provide an officer to help him with his defence, meaning he had to represent himself. To sum it up, his chances were hopeless before the trial had even started.

One record notes at least six witnesses who were brought in to confirm Bernard had deserted, while the officer reports tore shreds into his character. They described him as 'generally well behaved but an indifferent fighter, of weak intellect, who was incapable of understanding orders.' Another officer gave this shocking statement about Bernard: 'He seems of weak character and is worthless as a soldier.' A soldier who had known him before the war told the court that 'He was inclined to be rather stupid.' Just two pieces of paper covered Bernard's trial; it took just two pieces of paper to decide that this man should be sentenced to death. At 6.16 a.m. on 2 November 1916, Bernard McGeehan was shot by firing squad in Poperinghe, Belgium. He died instantly. He was buried at Poperinghe New Military Cemetery. One story tells of the cell where Bernard spent his final hours and how it was later discovered to have the word 'Derry' roughly inscribed on its wall, though it remains uncertain as to how true this is.

The trial makes depressing reading and there is no mention of any help being offered to Bernard at any time. Those giving evidence appear to have had great knowledge of Bernard's every weakness; his inability at fighting, his lack of understanding, his weakness of character, yet not one person suggested these as a reason for his nervousness. He was also the victim of bullying and it occurred to nobody at the trial that this could have made his nerves worse. When Bernard spoke

at his trial, he said the following, 'Ever since I joined up, all the men have made fun of me and I did not know what I was doing when I went away. Every time I go into the trenches they throw stones at me and pretend it is shrapnel and they call me all sorts of names. I have been out here 18 months and have had no leave.' These are the words of a twenty-eight-year-old man, and again it shows he had autistic traits. He appears different to his fellow men who bully him and convince him he is under attack in the trenches. Officers have described how he found it difficult to understand simple orders and he is described as being a bit thick and stupid. He was not thick or stupid; he just saw the world in a different way.

Bernard also had problems with machine gun and shellfire playing with his nerves. Today, one of the most commonly reported challenges for people with autism spectrum disorders (ASDs) is hypersensitivity to sound. Individuals have been known to cover their ears and flee from situations that might include undesirable sounds. Take this into account along with Bernard's problems with socialising and understanding commands, and it does appear that he fits the spectrum. Back in 1916 he was shown no compassion at his trial. Of course we know a lot more about ASD today than back then, but they clearly knew he was a bit different to the other men. Bernard had become little more than a nuisance to those around him at war, and when he came to trial his only use was seen as being an example and deterrent to others through his execution. Today Bernard's trial would break so many rules that it would be classed as a war crime and murder, but we cannot look at present rules against those of a war-torn 1916, as it was a different world back then. His trial was unfair and a sham; no man who walks around looking for his regiment before asking another unit directions where to find them is deserting.

Bernard McGeehan was clearly never going to thrive as a combat soldier; the Army, however, missed a great opportunity to use the talent that he shined in. Bernard's talent lay with horses and this was a war that relied on horse power. He could have been a big asset if used in this capacity and his skills would have helped the cause. Both horse and man would have gained from this union and helped each other to ease their nerves during these trying times.

In August 2006, the British Government granted posthumous pardons to 306 men who had been executed during the First World War; Bernard McGeehan was among them. The DFA (Department of Foreign Affairs) report on his trial and execution makes for emotional reading. The DFA report said,

> This would seem to be a man that needed the protection of the upper echelons of the military. It is a 'damning indictment' of those who confirmed the death sentence that they did not see a connection between character references describing McGeehan as incapable of understanding orders and his subsequent action in the trenches. It was well known that he was intellectually incapable of even the most basic of tasks.

In 2006, The Playhouse Theatre in Derry put on a production of *The Worthless Soldier*, written by Sam Starrett. It told the story of Bernard McGeehan, his trial

and his final hours before his death. The play proved such a success that it was later performed in Dublin. Tracey McRory wrote a piece of music titled 'Bernard' in honour of Bernard McGeehan.

> Pity me not as I wander alone, seeking only a place for my dreams.
> Hold no regrets, stem anger and sorrow. I am happy now, I am free.
> If you shall remember me, for who I was.
> Then I remain, I live on.

CHAPTER 5

HOGAN AND OWENS FAMILIES

On 28 March 1937, St Anthony's church on Scotland Road in Liverpool bore witness to the wedding of Bernard Hogan and Ellen Owens. Their marriage certificate shows both their fathers listed as deceased, the two men having been killed while fighting in Belgium during the First World War. This would have been a common occurrence during the time the children of those who died in the First World War began to marry. It is my hope that the story of Bernard and Ellen will stand as a reminder to all those who had their father or mother missing at their wedding due to war.

Bernard's father, John Hogan, was born in Dublin in September 1884, and came to Liverpool with his family as a small boy. His father, also named John, worked as a Cooper, and while in Ireland he had been employed making barrels for the Guinness Factory in Dublin. At first, the family resided in Blackstock Street before moving further along Scotland Road to No. 3 St George's Terrace off Comus Street. John's father passed away in 1895, leaving his mother Margaret to bring up the family. They struggled and, by 1901, Margaret was an inmate at the Brownlow Hill Workhouse. John had found work as a labourer and had also joined the Lancashire Fusilers Militia. Mary Flaherty lived in the same street as John; she was born in Rose Place in January 1884. They began a courtship before being married at nearby St Josephs church on 2 November 1908. After the wedding John moved in with Mary at No. 14 St George's Terrace; he was taken on as a pressman at Stanley Docks, while Mary found income from bag mending. They had three sons: John in 1910, Bernard in 1912 and Thomas in 1915. Mary had also had a tough early life, with her mother Winifred dying in a tragic accident. On 20 December 1898, Winifred was cooking a Christmas pudding at the family home at Myrtle View, and while sitting to relax in a chair next to the fireplace, she fell asleep and her dress caught alight. They were a poor family and had to take Winifred through the streets to the Liverpool Workhouse, as it was the only way she could receive treatment. Sadly she passed away the following day, aged just thirty-nine. Her husband Thomas had some kind of breakdown and could not cope, so Mary had to take charge of the family. She was aged just fourteen, yet she managed to get all her brothers and sisters apart from one out of the workhouse, and also cared for

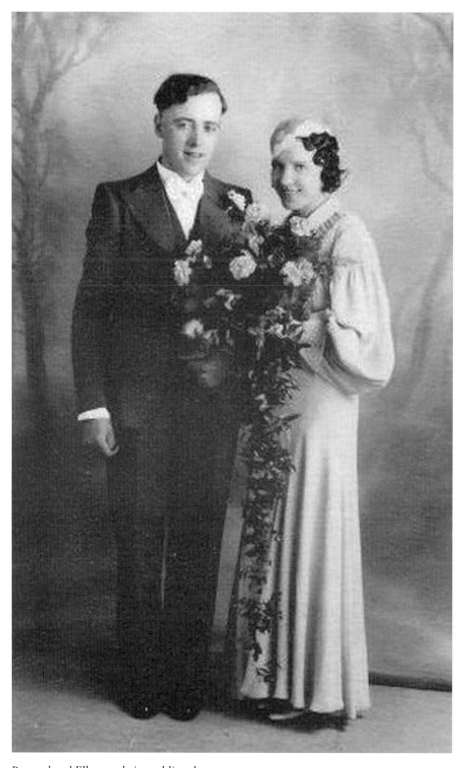

Bernard and Ellen on their wedding day.

her sick father. She managed to keep the family together, as well as holding down a job in service to a sea captain, so the family could survive. Sadly, the one child she could not save from the workhouse was her brother Thomas, who was sent to an orphanage where he died aged twelve.

At the outbreak of the First World War, John joined up full time with the Lancashire Fusiliers 4th battalion as Pte 4436. He was sent to Barrow-on-Furness for training, and while there received a crush and barbed wire injury to his right foot, which, after hospitalisation and operations in Barrow and Liverpool, warranted his discharge under King's Regulations as being 'no longer physically fit for war service'. In consequence, he was discharged on 20 October 1915, having served one year and forty-nine days with the Colours. That, of course, should have been the end of his war service, but while drinking with a friend in a public house, he made the decision, no matter how rashly, to try his luck again. His friend decided to enlist also, but was turned away as unfit. John was noted as being 5 foot 8 inches tall, with a chest measurement of 36 inches. He had the bust of a woman tattooed on the inside of his right wrist (his wife Mary also had this tattooed on her arm, so they must have had them done together – a nice sign of their affection for each other). By May 1916, conscription was in full swing, but by voluntary enlisting into a unit of your own choice and omitting to tell them you had served in the Militia/Special Reserve infantry prior to 1914, you would lengthen your odds to survive; by this time it would be well known that being in the infantry had a low rate of survival. John re-enlisted into the Royal Garrison Artillery as a gunner in June 1916. His was a voluntary enlistment, as opposed to conscription, plus he left out the fact that he had previous service in both the 5th Militia and 4th Battalion of the Lancashire Fusiliers, as well as seriously injuring his foot to the point of discharge a year earlier. Now under King's Regulations, his enlistment into the RGA was actually 'fraudulent', as he seems to have failed to declare all of this to the recruiter and, had he survived, it's possible that he would have had to forfeit his medals because of this, although he would have eventually got them back in the 1920s, pardoned by HM the King. John was posted to the RGA on 31 July 1916 and, on 7 November 1916, he became part of the 285th Siege Battery, who he served with until 27 February 1917, when he joined up with the 299th Siege Battery. He arrived in France with the 299th on the 5 April 1917.

In March 1917, Mary gave birth to a daughter, Winifred, while John was fighting in Europe. A photograph of the baby was taken and sent in a letter to John, but sadly he died before it arrived. At 9.30 a.m. on 24 June 1917, Gunner John Hogan 112913 was killed in action at Ypres by a shell splinter – he never got to see his daughter. John is buried at Ferme-Olivier Cemetery in Belgium. His daughter Winifred visited the grave of the father she never knew when she was in her eighties. Ford Cemetery in Liverpool has a grave for Mary's family, the Flahertys. On the bottom of the headstone is the inscription, 'Also Gunner John Hogan, R.G.A. Who was killed in action in France, June 24, 1917 aged 32 years.' Mary must not have known that he was buried in Belgium. It is very moving that they wanted his name put on the headstone.

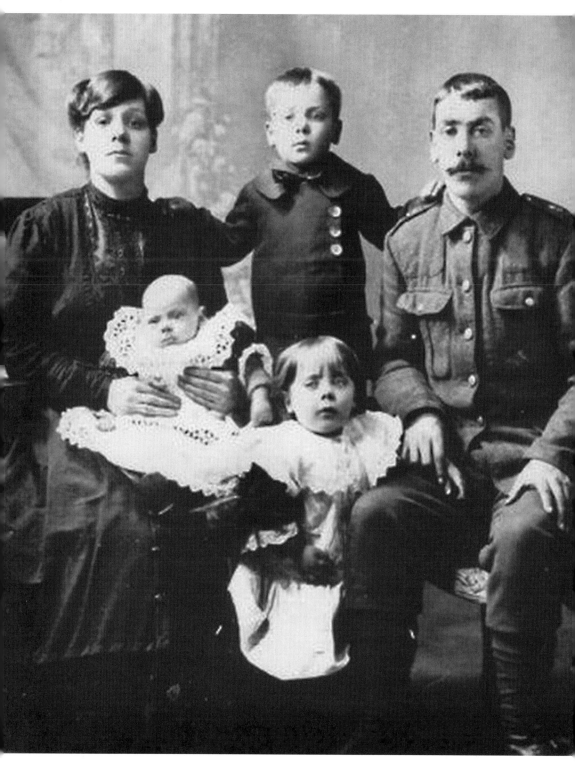

John Hogan, pictured in uniform with his wife Mary and their three boys in 1915.

John had only been at war a few weeks when he died, but he saw plenty of action. His regiment had been involved in the battle of Messines Ridge, where it supported the 2nd Army, which successfully took the ridge on 7 June. The battery moved to Poperinghe on 9 June and suffered heavy shelling by day and night on 15 June. The battery received instructions on 20 June to report to X1V Corps, and proceeded to a new position alongside a canal bank, where they came under the command of 85 HAG. The next few days were spent preparing their new position, until they came under shelling on the morning of 24 June. It is interesting to note that, had John not received his injury and remained with the 4th Lancashire Fusiliers, then he would have spent his war guarding the coastline at Barry and returned home to his family. Mary was a widow at the age of thirty-three with four children to bring up; she managed to keep them clothed and fed. It is said that Mary never accepted John's death and did not forgive him for joining up again. She never remarried and never owned a television set, but would listen to the radio and keep herself up to date on all the latest news, even reading the stock markets. She passed away in 1978 at the age of ninety-four. Mary's brother Bernard Flaherty had enlisted for war service with the King's Liverpool Regiment. Rumour has it that while serving on the Western Front, he decided he had had enough and somehow managed to get himself back to Liverpool. When his father found out, he told Bernard to rejoin or he would be shot. Bernard did as he was told and signed up again with the King's. How true this story is we can only guess, but records show a Bernard Flaherty from Liverpool with two medal cards under different service numbers for the King's Liverpool Regiment – one of the cards list him as a deserter.

Ellen Owens, known to all as Nellie, was the daughter of John Owens and Sarah Ann Cain, who had married at St Anthony's church on 26 August 1905. They had a son, Austin, in 1908, before Ellen was born in Bootle in 1912. Three of their other children had died at birth or in infancy. They first lived at No. 43 Brasenose Road in Bootle, before moving to the Vauxhall area of Liverpool at No. 145 Burlington Street. John Owens enlisted with the 2nd Battalion of the East Lancashire Regiment in London on 24 June 1896 as Pte 5101, giving his age as eighteen years and seven months, and his occupation as a Steward. He was noted as being 5 foot 4 and 1/4 inches tall, weighing 131 pounds, with a chest measurement of 33 inches. His complexion was fair, eyes grey and hair light brown. John's distinctive marks were noted; his eyebrows met, he had tattooed initials ('E. K.') on his forearm, a ring on the little finger of his left hand, and scars to both legs. His next of kin was given as his father, James. On 11 September 1897, he was posted to the depot in Preston before sailing to India on 20 December that same year, arriving in Rhaniket. He also spent time in Chakratta, Jullunder and Punjab. On 4 July 1901 he was granted an extra 1*d* a day pay, then, on 19 February 1903, he was confined to prison and faces a District Court Martial on 6 March, charged with 'Wilfully injuring his arms.' John was sentenced to 122 days of hard labour; the sentence was later reduced to fifty-six days. John also loses his extra 1*d* a day pay. He is released from prison back to his regiment on 30 April 1903. On 7 January 1904, he sails from

Poona and arrives in England on the 30th of that month. The charge of wilfully injuring his arms meant that John was carving his rifle stock, either creating a picture or writing names, probably through the boredom of sitting around in India without much to do. At Gosport on 3 February 1904, John is transferred to the 1st class Army Reserve after spending seven years and 225 days as a full-time soldier. His description on transfer gives his age as twenty-six years and one month, and he has grown to 5 foot 7 inches in height. John's chest measurement now reaches 38 inches and his waist 36 inches, with a hat size of 22.5 inches, and boot size 8.

John returned home, where he married Sarah and settled into family life. He found work as a coal heaver for the Cunard shipping line, loading the fuel coal onto the ships as they docked. When war broke out in August 1914, John, being a reserve, was called up by his regiment for service, rejoining the 1st battalion of the East Lancashires as Pte 7021. John and his battalion were sent to Colchester for field training and route marching, before proceeding to Harrow for platoon exercise. They arrived in Southampton on 21 August, before sailing just after midnight for France, aboard the *Brae Mar Castle*, arriving at Havre later that afternoon. They saw their first action on 26 August when they took up positions on La Carriere to the south of Beauvois. Here they came under heavy machine gun fire before an enemy attack forced them to retire to a sunken road, where, although attacked by shellfire and machine guns, they managed to hold their positions. German reinforcements were brought in to strengthen the attack and the East Lancs were ordered to retreat to the village of Ligny. To reach the village they had to cross a mile and a half of open country. As they did, the machine guns opened up along with the shell fire; they were sitting ducks and the casualties were high. As they reached Ligny, the enemy attacked, but they managed to push them back. Later that evening they were sent for rest at Elincourt; roll call showed over 250 of their men were either dead, wounded or missing. Almost everyone was either bruised or had been hit through their clothing. Their baptism into madness was complete.

Their war became a similar fate at different locations, in and out of trenches; attack, defend and bury your dead. They moved across to the Somme region, then back through northern France before orders were received on 15 October 1914 to advance on Nieppe. The next few months were spent in and out of the trenches as they defended the areas around Ploegsteert Wood and made attacks on the village of Le Gheer, while rest periods brought them back to Nieppe. As Christmas 1914 approached, John Owens and his battalion were positioned in trenches in front of Ploegsteert Wood. On Christmas morning, they heard the Germans singing carols and calling out to them; they saw them waving white cloths on sticks, and stared on as they emerged unarmed from their trenches to greet their enemy in friendship. It remains uncertain whether any of the men from the East Lancashire Battalion ventured out into no man's land to fraternise with their German counterparts, but it is certain that they saw what was going on, from the handshakes to the kicking of makeshift footballs as the men enjoyed Christmas. We can only guess as to what emotions John was feeling as he bore witness to this incredible event in history.

The battalion diary for 25 December 1914 reads, 'No shots being fired at all. An informal truce being held.'

By mid-April 1915, the 1st East Lancashires had moved into Belgium in readiness for the forthcoming second Battle of Ypres. They entered Elverdinghe on 4 May and billeted in the chateau grounds, the same *chateau* grounds that John Hogan would be billeted in just before his death in June 1917. Later that same day, they moved to the woods near Oosthoex, where they stayed until 8 May when they marched to Vlamertinghe and rested in the chateau grounds. That evening at 7.30 p.m., they moved on towards La Brique, arriving at its outskirts 2 hours later, where they were stopped and informed that the Germans had attacked the line, broken through and made it into Wieltze. The East Lancashires now received orders to join up with the Arglye and Sutherland Highlanders, and take up a reserve line of defence 700 yards to the east of Wieltze. They entered their trenches around 1.30 a.m. on 9 May; to their right were the Dublin Fusiliers and to their left the Monmouths, who were holding Mousetrap Farm with the 1st Rifle Brigade. Their lines were heavily shelled throughout the day, but no enemy attack came. The next few days were spent fixing up the trenches while the shells continued to fall around them, waiting for the German advance that they knew was coming.

The early hours of 13 May began with heavy rain, which continued throughout the day. At 3.30 a.m., the enemy started a huge bombardment of the lines – the East Lancashires had yet to experience such ferocious shelling; it continued until dawn, causing much damage to the breastworks, and took many casualties. The two platoons of the 1st Rifle Brigade that had taken up a position in Mousetrap Farm were almost all killed by the artillery fire; at one point over 100 shells had fallen on the farm in the space of 1 minute. At 7.00 a.m. the German infantry attacked, the East Lancashires managed to drive them off, but with severe loss to their own men. The Germans, however, had managed to enter Mousetrap Farm and set up their positions. The East Lancashires, with the assistance of the Essex Regiment that had moved up to support, now brought heavy rifle fire onto the farm and drove the enemy out. The farm was now neutral ground. At 8.00 p.m. that evening, the East Lancashires were sent up to take the farm; they were pushed back by the enemy, but a second attempt proved successful and they gained control of the farm, occupying the buildings and the trenches in front. During the day's fighting, Lt Salt had been wounded to the head, yet he stuck to his post, shooting many of the attacking enemy, including an officer who had demanded his surrender. He was later awarded the Military Medal for his actions. L/Cpl Thorne and Pte Cowburn took up a position at the bridge over the farm moat; both men were wounded, but they hung on and prevented the enemy from crossing. The men of the East Lancashires had been through hell this day; they had all shown bravery beyond their duty. They were relieved the following day at 11.00 p.m., roll call showed their casualties as 387 men killed, wounded, or missing. Sadly, John Owens was one of those who had lost his life in the action on 13 May.

Back in Liverpool, Sarah received the news that her husband would not be returning home and had to face up to life without him. She remarried to Richard

Sudworth on 12 October 1916 at Our Lady of Reconciliation church in Eldon Street. They moved to No. 24b Kew Street, off Scotland Road. A son also named Richard was born to them in 1919. Sarah wrote to the Army after the war, asking where John was buried, receiving the reply that he had been buried at a point north of St Jean outside of Ypres. It also mentioned that the battlefields were carefully being searched and if John's grave were located then details would be sent. They never found John and his body remains unknown – maybe he is one of those 'known only to God' in the nearby cemeteries, or maybe he remains in the area of Mousetrap Farm. John Owens is remembered on the Menin Gate Memorial and on the war memorial at Our Lady of Reconciliation church in Liverpool. Sarah worked as a cleaner at the Westmoreland Arms (later known as Dolly Hickey's Pub). She would clean the pews of St Anthony's church every day and also liked the odd tipple in a local pub. When drinking, she was known to sing 'Sandy Scored the Goal' in reference to Alex Sandy Young, who scored the winner for Everton in the 1906 FA Cup final. During the Second World War Blitz, when the air-raid sirens went off, Sarah would hurry everyone, including the men, into the air-raid shelter in Kew Street, then she would go back to her flat on the second floor and hide under the kitchen table. She had suffered from fits and when she took one, a spoon was placed into her mouth to stop her swallowing her tongue. In February 1945, after a few drinks in a local pub, Sarah returned home, singing as she climbed the stairs of her block. She fell, banging her head on the stone step. Her six-year-old grandson Bernard was watching from the top of the stairs all excited by his nanna's return home. Sarah was taken to hospital, where she died a few days later.

We now know about Bernard and Ellen's parents, and of how their fathers died fighting at war, but what of the couple themselves? Bernard was born on 1 August 1912. He was educated at Bishop Goss School before leaving, aged fourteen, to work as a labourer. He enjoyed playing snooker and football, and was a supporter of Everton FC. He never drank much, but did like a bet at the dog track much to his mother's dismay. Bernard was known as Barney and it is said that he was very handy with his fists when the need arose. Ellen was born on 11 January 1912 in Bootle, moving to the Scotland Road area as a young child. She was schooled at St Bridget's, where she did very well, before going to work as a chambermaid in hotels in North Wales.

After Bernard Hogan and Ellen Owens's wedding in 1937, they moved into No. 98 St Martins Cottages (the first council houses in Europe), off Silvester Street, and settled into their new life together. Bernard worked as a flagger for the local corporation, and was based at the Spencer Street depot. March 1938 saw them blessed with the birth of their son, also named Bernard. In 1939, war broke out and Bernard was called up to duty. He signed up with the 11th Field Regiment Royal Artillery on 6 December 1939 in Liverpool. On his service records his details note him as being 5 foot 5 inches tall, having brown hair and hazel eyes, size eight boots and a size seven hat. He had bad teeth, a mole 2 inches below his nipple and a swelling the size of a hazelnut above his right testicle. After passing his medical, he trained as a gunner before being posted to the 12th Field Regiment at Salisbury

Plains in Wiltshire, near to Stonehenge. On 16 May 1940 he was admitted, injured, to the No. 2 recovery station at Larkill; nothing was serious and he was soon back with his regiment. In June 1940, his regiment took charge of administered reception camps for Royal Artillery units that were returning from France. Other duties for the regiment at that time included being responsible for the local defence of Wiltshire and running test deployments in case of enemy attack.

The regiment was given orders to mobilize for overseas duty by 9 October 1940. They then made their way to Liverpool for passage. I wonder how Bernard felt sailing from his home city; did it bring him happiness or sadness? Where he would have sailed from was less than 1 mile from his home, and most of his family were living in this area. Did he get the chance to return home for one last goodbye, did loved ones come to wave him off: his mother Mary, sister Winnie, brothers John and Tommy, his wife Ellen and his little boy Bernard? On 29 October 1940, Bernard and his regiment boarded the HMT *Pasteur* for Gibraltar. For most on board it was their first look at Liverpool, for Bernard it was his last look at home as the ship sailed out of the River Mersey. On 6 November 1940 they arrived in Gibraltar, where they changed ships and boarded the HMS *Berwick* for passage to Malta, sailing the next day with Force F. They joined up with Force

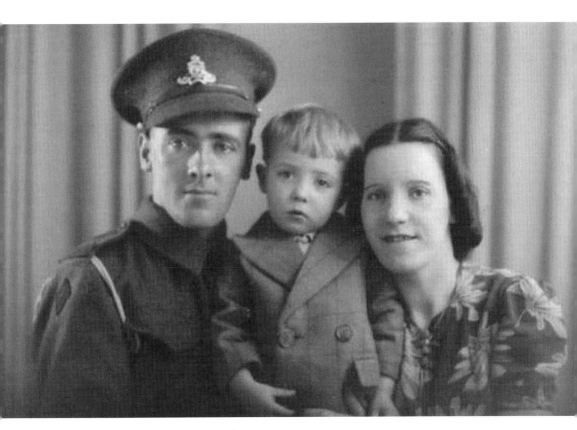

Bernard and Ellen with young Bernard.

H, then continued on to Malta. On 9 November, the ship came under attack in the Mediterranean and put up a successful defence; they also came under enemy submarine threat, yet no attack emerged. The next day they arrived in Malta and went into billets at Luqa.

On 28 October, Bernard's battery was deployed to Marsa, where they began the work of digging the gun positions and erecting camouflage. They also supported infantry formations in Malta, as well as being in charge of smokescreens for the defence of the Grand Harbour at Valletta. By 23 January 1941, Bernard was attached to the 222nd AA battery, 10 HAA, along with four officers and eighty ordinary ranked soldiers. They manned guns at Fleur De Lys in early 1941. They received an intelligence report on 1 April 1941, stating that a German invasion of Malta was about to happen. The troops, however, became very suspect of this report due to the date and were proved correct when nothing happened. Back in Liverpool, the bombing raids upon the city had become so severe that Ellen and young Bernard were evacuated to Holywell in North Wales. From here Ellen would write to her husband telling him about their son growing up and include photographs.

Bernard was involved in defending the Grand Harbour during constant night raids by enemy bombers between 21 April and 7 May 1941. As 1941 came to a close, the enemy bombing took place day and night, with the main targets being the airfields and harbours. 1942 would see an increase in the enemy bombing raids on Malta. Bernard and his regiment manned gun positions and helped rebuild airfields. Other duties were included when needed, as on 12 February 1942, when Pawla was hit by a major bombing attack, resulting in the death of over thirty civilians and the damage of almost 300 houses; the regiment went to help with the rescue and clear up operation. On 23 March 1942, they were sent to Marsaxlokk to protect HMS *Breconshire*, with orders to sink the ship if it caught fire from enemy action. Four days later the enemy bombed and sank the *Breconshire* and they were withdrawn.

Ellen had the constant worry, not only for her husband, but also for her two brothers who were serving – Austin with the Merchant Navy and Richard with the King's Liverpool Regiment. Her cousin Francis Cragg had enlisted with the Merchant Navy, serving aboard the anti-submarine trawler HMS *Bedfordshire*. German U-boats had been sinking shipping off the East Coast of America, and when the USA asked for help with defence, the *Bedfordshire* was part of the fleet sent to be used for patrol and escort work. On 11 May 1942, they were sent out after reports came in for a suspected U-boat off the coast of Ocracoke, North Carolina. HMS *Bedfordshire* and HMS *St Loman* went out together, but they had already been spotted by the German submarine. *St Loman* was attacked first, however; she saw the torpedoes coming and took evasive action. The *Bedfordshire* was not so lucky and, on the morning of 12 May 1942 at 5.40 a.m., two more torpedoes fired from U-558 found their target. The trawler stood no chance and sank with the loss of all thirty-five men on board, including eighteen-year-old Francis Cragg.

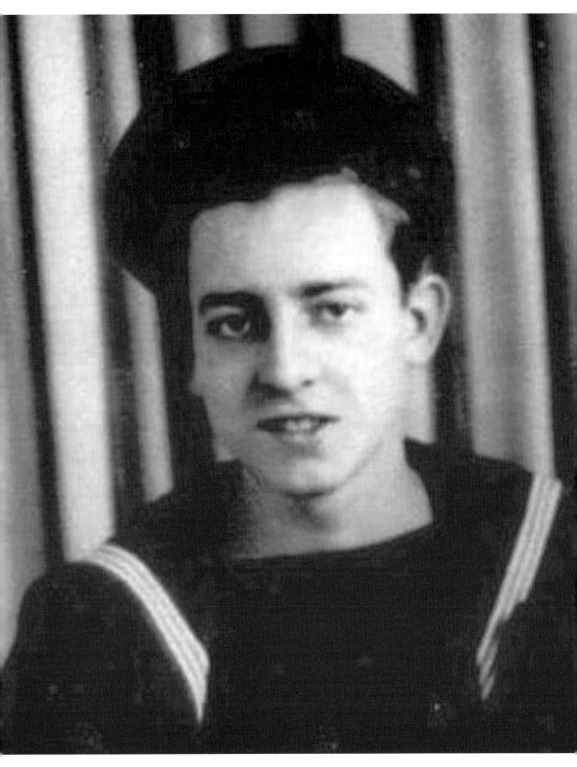

Francis Cragg pictured in uniform.

1942 saw the heaviest raids upon Malta as the enemy tried to bomb and starve her into submission. These small islands in the Mediterranean became subject to one of the largest bombing raids in history – the enemy wanted the total annihilation of Malta. For 154 days, it became a living hell, as day and night, the islands were bombarded; cities, towns, dockland harbours and airfields all became targets. Shipping trying to supply the island was sunk and without these supplies it could not survive; Malta was just two weeks from starvation at one point. Bernard was in the thick of all this, manning the AA guns, helping civilians, clearing rubble and doing his best to survive the madness. It was grim and horrific, and at times it must have seemed hopeless, yet they did it against all the odds; Malta held strong at all that was thrown at her. The civilians carried on, the troops and pilots fought to defend; ship by ship hobbled in, they all stood together and refused to be defeated. The events became know as the Siege of Malta. On 15 April 1942, King George VI awarded the George Cross Medal to Malta and her citizens in recognition of their bravery. Due to the constant raids, no official ceremony was held until 13 September 1942, when, in the ruins of the Palace Square in Valletta, the Chief Justice of Malta, Sir George Borg, accepted the medal on behalf of Malta's people. Bernard was present at this ceremony.

By July of 1942 the enemy attacks began to slacken a little, as the RAF began to control the skies. Bernard's regiment was used for smoke screening at the Grand Harbour, manned field and AA guns, provided vehicles for duties at Luqa airfield, helped with the unloading of ships, supported the 1st Dorset Regiment in patrolling the coast against enemy activities, and assisted civilians with debris removal and building. 1943 came and the regiment remained responsible for the defence of the coastline in case of invasion, smokescreening, anti-parachutist roles and general duties. The island was now in preparation to receive troops of the 8th Army as they began their advance into Italy. Bernard and his regiment helped set up two camps that each accommodated 1,000 men. On 6 June 1943, the camps were ready and, by the 9th, the two camps were full and the regiment were employed to maintain them. The troops of the 8th Army had left Malta by 24 July and the regiment was no longer needed to maintain them. That same day, the whole regiment was brought together for the first time since they had left the UK in 1940, when they moved to No. 4 Camp at Mekkieha. In August 1943, a 'Strength Through Joy' week was arranged for the weary troops of the regiment, which included activities such as cricket, swimming, athletics, water polo and concerts.

Bernard was admitted to hospital on 13 September 1943. Just five days later, the whole regiment boarded the HMS *Alcinous* at the Grand Harbour and sailed out of Malta for a well-deserved rest at Boigie in Algiers. Bernard, however, was still in hospital, where he remained until being discharged on 27 October 1943. In Army terms he was now 'homeless'; his regiment was resting and training in North Africa and he was still in Malta. The Army decided that he too deserved a rest and, on 29 October, three years to the day that he had sailed out of Liverpool, they put him on a ship back home and he sailed out of Malta. His ship had just left the island when it received orders to sail to Sicily. We do not know if Bernard

Bernard Hogan at the J. Cassar Studio in Hamrun, Malta.

took part in any action in Sicily, but his leave was cancelled and he joined the push into Italy.

He landed in the Salerno/Naples bay after being placed with the 51st Medium, which was with 56th (Black Cat) Division for the invasion at Salerno, attached to the 5th US Army. They then followed various battles towards Naples before they were switched over the other side of Italy to join the 8th Army, near the Sangro River, for that awful battle. They then went back to 56th Division for the battle of Minturno. In January 1944, the regiment was positioned to support an attack by 56 Division on two mountains, Sujo and Dimiano, lying to the west of Monte Cassino. This was as part of the prolonged and bitter fighting leading to the Second Battle of Cassino. Bernard was near the village of Lauro with his unit by coincidence, although, of course, they did not know at the time that Spike Milligan was serving with his 56 Heavy Regiment RA firing alongside them near Lauro, his guns thumping away with theirs on the same task. Just after 1.00 a.m. on the morning of January 25 1944, an enemy shell burst near to their guns and Bernard was hit. Sadly, he was killed outright. Gnr Bernard Hogan was buried at Minturno War Cemetery in Italy.

While in Italy, Bernard had ordered flowers to be sent to his wife Ellen for Valentines Day. Ellen had by now returned to Liverpool with her son as the bombing raids had ceased. On 18 February 1945 Ellen answered a knock at her door, and was handed the telegram informing her of her husband's death. Her little boy knew what had happened, as his mother and grandmother began crying and screaming. The following day Bernard's flowers arrived – how sad, but nice this must have been for Ellen.

Ellen was now living at No. 24b Kew Street in Liverpool, bringing up her little boy who had started school at St Anthony's. Ellen would tie a cloth around little Bernard like a nappy, put wax on the lino floor, then pull him around the room by his ankles. They had great fun doing this and an incredibly clean floor. The were very close to each other, with Bernard even insisting on going for his mother's ciggies, taking the short run to the Throstles Nest pub, where, behind the door, sat the ciggy lady who would wrap five smokes in a bit of paper. Ellen's mother died in 1945 just before the war ended, while her two brothers returned home safe. Austin remained in the Merchant Navy, while Richard returned to Liverpool after serving in France and Burma. When he first came home, he stayed with his sister Ellen, who would come to comfort him when he woke up screaming from his nightmares.

Ellen found a job in the office at Kirkland and Jennings' bakery on Hardman Street, where she met Arthur Patrick Graley who worked in the bakery. They fell in love and were married in 1947 at St Patrick's church in Park Place. Their first child Kenneth was born in 1948. He was very ill and had to be admitted into Alder Hey children's hospital. Sadly he passed away aged just three weeks and was buried with his Nanna Sarah in Ford cemetery. Yet another tragedy for Ellen – how did she cope with what life threw at her? She was an incredible lady. Ellen and Arthur moved to King Gardens in the Dingle where they had four more children,

Arthur, Jimmy, Michael and Anne. They later moved down into the Childwall Valley area where they settled and spent their retirement. Arthur passed away in 1984 and Ellen in 1990, and they are buried together at Allerton cemetery.

Ellen's son Bernard had kept his surname as Hogan after his mother remarried. He later moved schools to St Patrick's, where he achieved good results and showed great skill at woodwork. He was also proving to have great potential as a footballer, playing as a striker for St Patrick's School then later their church team. His goalscoring was so prolific (nine goals in one game) that he was tipped to succeed as a professional player. He was football mad, supporting Everton, and also a big cricket fan (he followed Lancashire). Bernard found work as a wood turner until he was called up for national service in 1956, serving with the 19th Field Regiment of the Royal Artillery in Hong Kong and Germany. The Army had noticed his football talents and had him playing in exhibition matches. While playing in a game in Hong Kong, he injured his knee and should have rested it, yet the Army wanted him playing to show him off. He kept playing, being injected with cortisone to ease the pain. When he returned home after service, his knee was so damaged from playing through the pain that he had no chance of competing at the top level – a promising football career was over.

Bernard was employed at Standards Bottle Works in Garston, where his leadership skills were showcased when he became shop steward. It was also here that he met his good friend Tommy Moore, who had once been the drummer with The Beatles. Bernard later went on to work for the council cleansing department, where he became deputy union leader to Matty Cullinan. The two became close friends, fighting for workers' rights and, along with Matty's wife Josie, enjoying a drink and a sing-song. Bernard was a member of the Labour Party and fought Thatcher with a vengeance. He could be seen on picket lines and marches for council workers, coalminers and dockers. He helped many jailed miners to get legal help and justice. He fought alongside the forty-seven banned Liverpool councillors, and it was he that closed the doors of the town hall in Liverpool for the sit in. Bernard took up bowls in later life as his knee got worse, becoming very good at it and winning many trophies. He was a member of the Coronation pub bowling team. He also loved to jive, forever dragging his sister Ann up for a dance. He passed away in 2006, aged sixty-eight.

CHAPTER 6

OFF WE GO AGAIN

They said that the First World War was the war to end all wars, but just twenty years after its end, another world war was starting. This war would bring further devastation to millions of people as it spread to many corners. Again, the call was answered by the people of Merseyside to serve their country. Our pride in them shall never falter.

Stanley, John and Leslie, the three sons of John and Lucy Roberts, all perished at sea in 1941 aboard the SS *Arakaka*. Unmarried, all had been sailors virtually from the time that they left Haygreen School in Wavertree. Their father, John Roberts, had also been lost at sea in the North Atlantic, aboard the ship *Derville,* after leaving Newfoundland on 15 October 1925. A cruel twist of fate was to see John's sons also perish off the coast of Newfoundland. The *Arakaka* was a British steam merchant ship, owned by Booker Bros, McConnell & Co. Ltd in Liverpool. She had been hired by the admiralty to operate as a weather ship in the North Atlantic. She had completed five voyages before setting sail in late May 1941 on her sixth and fateful mission. The last signal received from the ship came on 22 June, the same day that the German submarine U-77 spotted her. At 22.36 that night, the *Arakaka* received a hit to her engine room from a U-77 torpedo. She sank in under 1 minute; Stanley, twenty-six, John, twenty-four, and Leslie, aged twenty-one, all died in the attack. The three brothers are commemorated together on Panel 9 at the Tower Hill Memorial in London.

William Daley was born after the First World War in 1918; his family lived in Elstow Street before moving to Tintern Street as the family grew. He was a bright young boy and could have gone to college, but his mother said she could not afford it. As soon as his schooling ended, he was put to work in a drum manufacturers, where he served an apprenticeship as a sheet metal worker. Through his best mate, he met Jessie, the girl he was later to make his wife. Bill was working as a foreman in Watsons in Liverpool; they were making parts for the aircraft manufacturers. He tried to get into the Royal Navy like his best mate Tom Hengler, but because he was a skilled tradesman, he was not allowed to leave his job. Frustrated in his attempts to serve in the military, he volunteered for the Auxiliary Fire Service. During the May Blitz his feet hardly ever touched the ground, as there were so many fires and

not enough firefighters. He was in a team that operated mobile suction pumps that were mounted on a two-wheel trailer. These units could be hauled by small vans and they got their water from fire hydrants or EWS (Emergency Water Supply) tanks. Bill only spoke of the sights he encountered during the Blitz to his wife. He would be away for days at a time and when he came home he would be exhausted. He still had to go to work at Watsons, so he was either working or sleeping. One time he came home wrecked after attending to fires at a street in Kirkdale, where a couple of houses had been bombed and there were a few teams of firemen clearing the rubble and dousing the fires. As Bill was clearing some rubble, he came across the body of a close friend's young son; he was traumatised and he could hardly talk by the time he returned home.

Harold Frederick Claydon served with the Liverpool City Police as Sgt 36 A. He was awarded the George Medal for rescuing several people from bombed buildings in Liverpool on the night of 12/13 March 1941, with his awarded being gazetted on 6 June 1941. Arriving at the scene, Harold was informed that people were trapped below the debris. He tunnelled 20 feet through rubble and brought out two women. He then made the tunnel strong with wood and masonry, and succeeded in saving another woman who was buried. Harold was overcome from the fumes and was ordered to rest. As soon as he had recovered, he continued with his rescue work, despite being warned of the danger from the fumes. Upon finding a large piece of wood blocking further entry along the tunnel, Harold sought out a saw, returned to the tunnel and, lying in a cramped space, sawed through the block of wood and released two more people. He then moved more of the rubble to free a child and a man, before clearing an area to allow others to continue the rescue. His brave actions this night resulted in ten people being saved – a truly heroic deed.

In November 1923, twenty-five-year-old Thomas Emery married Annie Florence Clark in Liverpool. They are known to have had three children. In November 1926, his brother Robert Emery, now also aged twenty-five, married Annie Louise Evans and they also had three children. Both men are believed to have had impaired hearing, which made them unfit for combatant duties in the Armed Forces. There were a number of similarities between the two brothers that would sadly continue into the Second World War. On the night of 3 May 1941, while serving as a volunteer fire watcher, Robert was killed during an air raid. His death certificate indicates that his body was found on 5 May at the corner of Hawthorne Grove and Dorothy Street. At the time, Robert was living at No. 27 Plimsoll Street in Liverpool. His brother Thomas literally disappeared the same night on his way home from working late, but his body was either never found or identified; his 'named' death is not in the casualty lists for Liverpool or in the General Registry Office death index. If his body was found but never identified, he would have been interred on 13 May 1941 in a common grave in Anfield Cemetery, together with 549 other unidentified casualties, who became known as the 'Unknown Warriors of the Battle of Britain'.

Alfred Bernard Smith was born in Liverpool in Butte Street, at his grandmother's house on 25 September 1922. Seven years later, the family moved over the Mersey

Alfred Bernard Smith.

to the Wirral, living around the Moreton and Birkenhead areas before returning to Liverpool and living at No. 108 Cambridge Road, Waterloo. Alfred volunteered for the Royal Air Force in 1941 with the service number 1457778. He served in Scotland, then Cairo, Egypt, and finally Nairobi in Kenya before being discharged in 1946. He was a Leading Aircraftman (LAC) and wireless operator. He married Jean Irene Smith in Crosby on 28 February 1953 and they had three children together. The family eventually moved to Sandiway in Northwich, Cheshire. Alfred got a job at Imperial Chemical Industries (I. C. I) Northwich. He worked there for some years and then became a van salesman for Robert's Bakery, before working as a milkman for Express Dairies Northwich. He retired from work at the age of sixty. In November 2012, Alfred passed away peacefully at the age of ninety, having celebrated his 90th birthday just a few weeks earlier. His brother Arnold had also joined the RAF on the outbreak of war and was posted in November 1940 as a sergeant. In April 1942, he was promoted to flight sergeant and on 20 February 1942, he was posted to 106 Squadron. Arnold flew many missions, mainly over Germany. On 1 August 1942, he took off on the flight that would sadly claim his life. Lancaster R5604 took off from RAF Coningsby at 00.55 hours on the night of 31/1 August 1942, as part of a twenty-one-strong squadron instructed to bomb Dusseldorf in Germany. Nothing was heard from the aircraft after take off, and it failed to return to base. The aircraft crashed at Lovenach, close to Cologne in Germany, and all the crew were killed. Arnold has no known grave, but is commemorated on the Memorial to the Missing at Runnymede in Surrey.

Glenys Hughes was evacuated during the war with her school, the Morrison. On the way, the teacher asked where they were going and when she was told it was Bagillt, she said, 'Oh, what a godforsaken place that is!' Glenys stayed with people who she called her Uncle Fred and Aunty Vi; she used to take him his lunch having to walk all the way into the village with it. She used to go outside with the other children and watch dogfights in the air, and Uncle Fred would come and send them back inside. Sometimes the planes dropped their spare bombs as they were on their way home, and one dropped on the farm next to theirs. People were killed in the houses either side of the bomb: Mr Salter and his son, Ronald died, Mrs Salter was injured, and the lady on the other side was killed too. Her sister Dilys, who had stayed home in Blantyre Road in Wavertree, told of how their mother found out about the bombing in Bagillt when a little piece in the *Liverpool Echo* mentioned it, and somebody said, 'Oh look, that's the same name as the family Glenys is with.' She then sent a telegram to find out what had happened, only she signed it 'mother', and Uncle Fred thought it was from his mother, so he replied to her and our mother didn't hear anything back! She went straight away and brought Glenys home as the house was unsafe and they were staying with Vi's sister and her family. Glenys was not evacuated again after that. Their brother John was evacuated twice. The first time he was put with a family near Glenys and they could not really be bothered with him. He would show up at her house before breakfast because they had turned him out for the day – he was only six. Then an elderly couple Robert Davy and Jemima Edwards asked if they could take him

in, so he went to them and they spoiled him rotten. A lot of the children who had been evacuated with Glenys returned home early, including her friend Dot Wilson. Glenys attended numerous schools during her evacuation, the first being in Flint, where they only had candles to light the classrooms. She then went to the Merlin School in Bagillt and, after a while, the Boot School (Boot was the district name), before moving on to Flint High School when she turned eleven. On her return to Liverpool she had to take the test again to go to Arundel Avenue, now St Hilda's. The headteacher and the assistant head were both nuns.

Tommy Flynn.

Tommy Flynn was born in Liverpool and lived at No. 68 Windsor Road in Tuebrook. He was a keen boxer and won a title belt in 1941. Tommy was married to Anna Louise. He signed up with the Liverpool King's Regiment in the Second World War and sadly died on 19 March 1943 in Kenya. He is buried at Gilgil War Cemetery. A transcription error on the records lists Tommy as serving with the 19th Battalion of the King's Liverpool Regiment, when in fact he was serving with the 19th King's African Rifles, though he was attached to this regiment and was still a King's Liverpool man. The African troops very often had British (white) sergeants, with the NCOs underneath being made up of black soldiers. Tommy was a sergeant. Information for the 19th King's African Rifles is hard to come by, so it remains unclear as to what Tommy was doing while he was with them, or the events that led to his death.

The comedian Stan Boardman is well known for his jokes about 'the Germans bombed our chippy'. Sometimes humour hides tragedy, and this was certainly the case with Stan. He was evacuated to Wrexham during the Second World War to escape the bombing in Liverpool. When the bombs failed to come, the family returned to the city, only for a bombing campaign to begin. On 3 May 1941, the sirens went off and Stan, his brother Tommy, sister Ada, mother Lily and a family friend, Mary Monroe, all went into the air-raid shelter in Back Castle Street where they lived. A bomb hit the shelter, causing mayhem. Mary Monroe was killed, while young Tommy was taken injured to Liverpool Stanley Hospital along with his mother. Lily only needed stitches, but her son Tommy was so seriously wounded that he died the following day aged just six. Stan's family home in the Kirkdale area of Liverpool had backed onto a fish and chip shop, and was also bombed during the war. His dad and grandad would always say, 'The Germans bombed our chippy', as Stan was growing up and he later brought it into his comedy act.

Leslie Newnes was born on 15 June 1919 in Toxteth Park, Liverpool. His parents were John and Lilian; the family lived in Gregory Way in Childwall, between Rocky Lane and Childwall Valley Road. Leslie had joined the Liverpool Scottish Territorials based in Fraser Street off London Road. By 1942, he was with the Seaforth Highlanders. Leslie had fought across North Africa in those awful battles before sailing on 6 July 1943 into Valletta, Malta, for a short rest before going on to Sicily for the invasion. On the morning of 13 July 1943, the 5th Seaforth Highlanders were at the front of their battalion as it moved into the town of Francofonte. At first all was quiet, and although some sniping was reported by the advance party, it was not enough to worry them. As they moved on, they approached a tight hairpin bend in the road into the village. Little did they know that they were going straight into a trap. The crack troops of the German 2nd Parachute Regiment had anticipated the advance and were lying in wait. As the leading Seaforths carrier moved along the hairpin road, the enemy fire opened up and the carrier took a full barrage of hits from the paratroopers positioned in the nearby cemetery. All its crew were killed. As the Seaforths prepared to return the fire, the Germans moved their tanks up, the hairpin came under heavy fire and the men of the 5th Seaforths had to leave their carriers and take cover among

the olive and orange trees. They managed to hold their position throughout the fight, but at a huge cost. Leslie Newnes was one of those killed during this action; he is buried at Syracuse War Cemetery in Sicily.

Many people consider Bob Paisley as the greatest Liverpool FC manager of all time – he certainly brought them plenty of success. During the Second World War Bob served as an anti tank gunner with the 73rd Regiment of the Royal Artillery, fighting at the relief of Tobruk and the victory at El Alamein in North Africa, before going in for the invasion of Italy. While on duty, Bob was given the dreadful news that his younger brother Alan had died from scarlet fever aged just fifteen. So distraught was Bob that he left his position and wandered around in a stunned state. Within moments a shell exploded, hitting the position that Bob had occupied; the tragic news of his brother had saved his own life. The war gave Bob a taste of the Scouse character and humour that he would later encounter as Liverpool manager, for a great number of the men in his regiment were Merseysiders.

Husband and wife Joseph Patrick and Norah Ann Fagan played their parts during the Second World War. Norah worked in the munitions factories, while Joseph served with the Royal Navy. He would tell his children about sailing around the Cape of Good Hope at Africa's southernmost tip, then up the Suez canal, spending time in Aden in South Yemen, Port Said and Alexandria in Egypt, and Tobruk in Libya. When he was in Alexandria, Joseph was in a circle of shipmates when he felt

Leslie Newnes, fourth from left, in full Highland dress. The tents indicate that they are attending training camp.

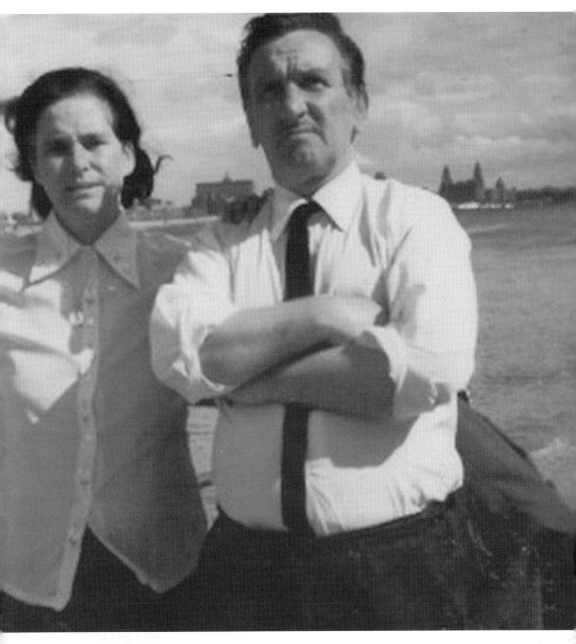

Joseph and Norah Fagan.

a tap on his shoulder and an, 'Alright Joe.' It was his brother-in-law Joey Wilson – small world, eh? Joey Wilson served with the 8th Army through North Africa and Italy. They all returned home safely from the war to their homes in the Scotland Road area of Liverpool.

Gwynne Jones and Owen Tom Williams (known as O. T.) grew up on the Isle

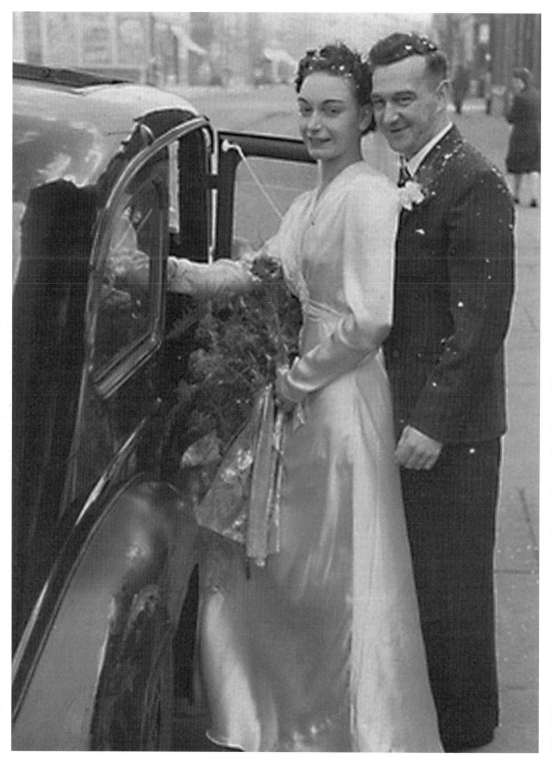

Gwynne Jones and Dorothy Hobson on their wedding day.

of Anglesey, where they formed a great friendship. They served together during the Second World War in the Merchant Navy. While aboard an unknown vessel that carried the fuel for the warships, they were spotted and torpedoed by a German U-Boat. A piece of shrapnel hit O. T. and almost cut him in half. Gwynne physically picked his friend up and held him together with no regard for his own life. They were shipwrecked and rescued before landing in Southampton, where they were taken to hospital. O. T. was in a terrible state, but the doctors managed to save him; he spent a long time in hospital during his recovery. During this recuperation, O. T. was tended to by a nurse for quite some time; they fell in love, married and settled in Southampton. O. T. had to wear a special girdle for the rest of his life to help keep him upright, but he always paid tribute and was grateful to his good friend Gwynne for saving his life and allowing him to have a life with the lady he loved. Gwynne Jones was discharged as unfit for service; he suffered severe shell shock and trauma. When he first moved to Liverpool, he was too traumatised to even go on the ferry,

The Land Army Badge awarded to Dorothy Jones.

but he got over it eventually. Gwynne married Dorothy Hobson on 28 September 1948 at St Saviour's church in Anfield. Dorothy had served in the Land Army during the Second World War and, in later years, was awarded a badge for her service.

Stanley Williams was a desert rat and served in an anti-tank unit. He was fighting in Burma when he ran out of bullets; he was then chased by Japanese soldiers and, while trying to escape, he fell into a pit full of excrement – the soldiers tailing him could not stop laughing and that is the reason Stanley was not shot. He was captured and spent time at Rangoon Jail, where he suffered badly. On returning home to the Dingle, his back was heavily scarred, so much so that there was not on inch of flesh upon his back that was not a scar. He had almost gone crazy with his treatment there. Stanley passed away in 1993.

Ernest Arthur Quarless was born in Liverpool on 9 October 1905 to John Isiah Quarless and Elizabeth Lawrence. John was a seaman who was born in Barbados, his parents were John Henry Quarless and Mary Rosetta Prescott and they may have been born into slavery – John's grandparents probably were. Elizabeth was the daughter of Abraham Lawrence, a Jamaican seaman, who, along with her mother Alice, kept boarding houses in Upper Pitt Street and Kent Street. Ernest was educated at Winsor CP School in Upper Hill Street. A school record notes him being listed there at the start of the academic year in August 1916. He later joined the Merchant Navy as a cook, working for the Union Castle Line with whom he travelled to most parts of the world. In Liverpool, Ernest married Evelyn Sharpe in 1941, and they set up home in Watford Road, Anfield. The couple had three children, George, Anita and Reva. His time at sea kept him away for long periods and would have left Evelyn full of worry with a war raging. He would be home for around three months before returning to the sea.

Ernest returned to the seas when he signed up on 23 March 1944 with the *Llangibby Castle*, a former passenger liner that had been converted into a landing ship. Ernest's ship book lists his port of call as 'Special operation for the liberation of Europe'. Ernest and the *Llangibby Castle* were moving troops around the Mediterranean during this very dangerous time. On 6 June 1944 they took part in the Normandy landings, carrying Canadian troops to Juno Beach, where ten of the ship's eighteen landing craft were lost during the first wave. This left them with only eight landing craft to deploy the second wave of men; they managed to do it before heading to Southampton. Later, they landed troops on to Omaha and Utah Beach, and also at Le Havre. They had practiced for D-Day at Bracklesham Bay in West Sussex. So, Ernest was in the thick of the madness during the Normandy Landings. The ship survived and Ernest signed off when they docked in Southampton on 29 August 1944. Did Ernest see something on this last trip? Did he witness the horrors of the Normandy landings? Did he realise just how bad the dangers had become and wonder what his family would do if he was killed? Something in Ernest had changed, for when his ship docked in Southampton, he resigned and returned home. His Merchant Navy career was over. Ernest found a job on the docks as a labourer, where he stayed until he retired. After retirement he helped run the local pensioners club. He passed away on 14 May 1988, aged eighty-two.

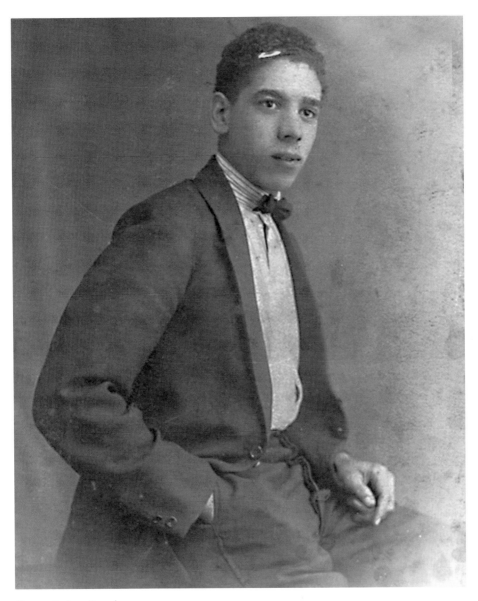

Ernest Arthur Quarless.

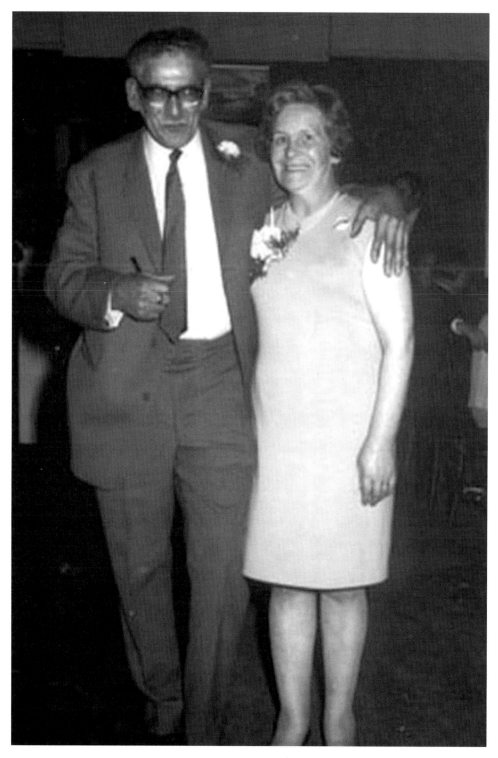

Ernest and Evelyn Quarless.

Walter Pritchard was born in Liverpool in 1916 to Alexander Pritchard and Margaret Wilton. His father was serving with the 5th Battalion of the King's Liverpool Regiment when he was killed in action on 4 June 1916, near to Arras in France. Walter was just a few months old when his father died, it is unlikely that the two ever met each other. In 1920, Margaret remarried to Alexander Hutchinson in Liverpool; they had three daughters, Ann, Elizabeth and Margaret. The family lived at No. 32 Simpson Street, where the girls doted after their only brother. Walter attended St Vincent's De Paul School, before training as a French polisher and working as a delivery driver for Lyons Bakeries. He played football for a club called Simpson United and was a big Everton fan. Walter married Catherine Anderson in Liverpool in 1937; they moved into the flat above Catherine's mum's haberdashery shop in Park Lane, and had two children, Janet and John. During the Second World War, Walter served with the 10th Royal Hussars as Tpr 3716882. He went right through Egypt and fought at El Alamein, before sailing into Naples on 27 March 1944 aboard the *Durban Castle,* as part of the Italy invasion force. When news of the D-Day invasion reached home, Walter's sister Margaret was convinced he was taking part in it all. She visited her friend in Simpson Street and they sat in the doorway waiting for news about him; of course he was in Italy, but they would have had no idea about this. Just four weeks after his arrival in Italy, Walter died on 20 June 1944. He was buried at Bari War Cemetery. The circumstances surrounding his death remain unknown, the family believed that he died in an accident and that the Army were keeping details from them. Walter's mother was told that he was driving an Italian prisoner of war back in an armoured car when it crashed or turned over, but they don't know if the prisoner did something or if it was just an accident. The regiment was involved in no battles around the time of Walter's death and no air raids occurred, as, by that time, the Luftwaffe were all back in Germany. The only conclusion is that Walter died by accident or from illness. His sisters Margaret and Elizabeth later made the journey to Bari in Italy to visit their beloved brother.

Edward McCaffrey was born on 19 October 1918 at O'Donovan Terrace, Hook Street, Scotland Road, to Joseph and Julia McCaffrey. He was a pupil at St Sylvester's School and, on leaving education, he joined the Merchant Navy. Edward was engaged to his sweetheart and they planned to marry on his return from war service. In 1944 Edward was serving aboard the SS *Wayfarer*. The ship had left Port Said, Egypt, for the UK, carrying a cargo of copper. On the evening of 19 August 1944, the *Wayfarer* was spotted by U-Boat 862, which began to torpedo the ship. The *Wayfarer*'s master, John Wales, sent the ship into zig-zag motions and managed to avoid the oncoming fire. They managed to escape, but the U-boat still had them in his sights. Ninety minutes later, Heinrich Timm, commander of U-Boat 862, spotted the *Wayfarer* and again fired upon her. There was no chance of escape and she received a fatal hit to her port side, sinking 90 miles off the coast of Mozambique. Edward McCaffrey lost his life during the sinking; he is remembered on the Tower Hill Memorial in London.

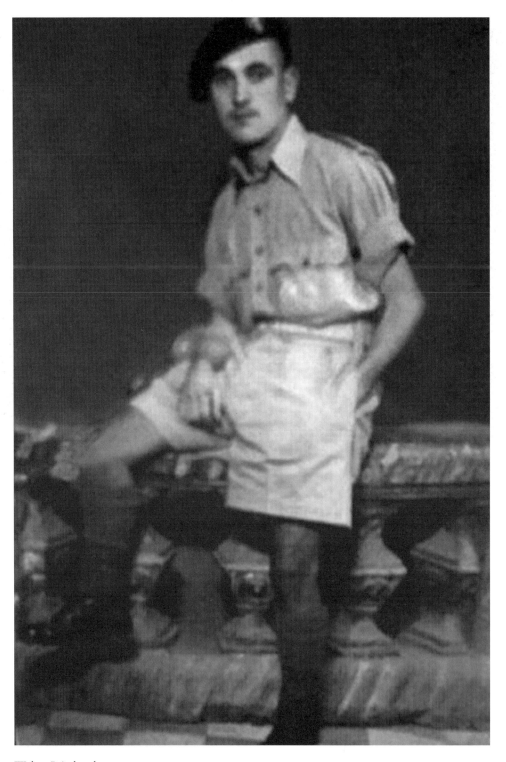

Walter Pritchard.

The bricked-up house in Simpson Street, where Walter Pritchard's sister Margaret sat in the doorway with her friend, waiting for news about her brother and believing he was involved in the D-Day landings.

John Sutton was born in the Hornby Street area in 1905. Known later in life as Big John, he married Ellen Shannon in 1927, and they lived mainly in the Silvester Street area during their married life together. John started his working life at Fairries, which was then taken over by Tate and Lyle, where he stayed until retirement. He was over thirty-five years old when war broke out, and by then had five children. This put him out of the range of conscription that was introduced at the outbreak. He also worked in the food industry, which was an excused service industry, as well as being a member of the Auxiliary Fire Service (AFS) when he was off shift from his normal job. One day he received an envelope containing a white feather in the post; this apparently virtually accused him of cowardice. He immediately went to the Royal Navy recruitment office and signed up. John served on the minesweepers from 1940 until demob in 1945, during which time three of his vessels were torpedoed or hit mines on the Russian Convoy runs. He was awarded 'oak leaves', having been mentioned in despatches for bravery under fire. John always suspected someone he knew as the person who had sent

the anonymous letter and, strangely enough, that gentleman never served in the services, claiming he had bad health. From his exposure in the North Sea following those sinkings, John suffered from bronchial pneumonia throughout the rest of his life, but nobody would ever hear him complain.

James Brighouse was a 1st class stoker serving with the Royal Navy, his service number being D/KX 108775. He died on 13 May 1945 and is buried at Ambon War Cemetery in Indonesia. He was the son of William John and Emma Brighouse. He worked in Liverpool as a Mill labourer. He was serving aboard the *Exeter* when it was sunk in the Java Sea, and he was taken prisoner by the Japanese. He remained a prisoner until just before the end of the war, when he died of beri beri. If he had eaten brown rice, he may have lived. While in the prisoner of war camp, they made a pact that if anyone got out at the end, they would visit the families of those that did not make it. True to their word, a few of them did visit James's parents in Liverpool after the war to tell them all about him. He had beri beri three times, but this third time it took his life, right at the end of the war.

Liverpool with its thriving and bustling seaport, and the many Chinese seamen looking for work – they just had to come together. When the Alfred Holt & Co., Blue Funnel Line operated a shipping line as a trade link between Britain and China, the deal was set. Many Chinese came to Liverpool to work the line and, as the years passed, some settled within the city, married local girls and set up business premises. Other notable employers of the Chinese seamen were the Anglo-Saxon Petroleum and Ben Line companies.

Almost 20,000 Chinese seamen worked out of Liverpool during the Second World War, helping to supply the country and the troops abroad, bravely taking to the seas that were full of danger due to enemy submarines, warships, planes and mines. They played a vital role in the allied victory. Their efforts, however, were not reflected in their pay, which was around one third of the British workers', and if a Chinese seamen lost his life at sea, his family would receive far less compensation than others. The unions held strikes to try and obtain the men a fairer pay deal, and to improve the working conditions.

At the war's end, the Chinese workers should have been treated as heroes. Instead, their pay was reduced by the shipping companies and they found it nigh on impossible to survive. As if this treatment was not bad enough, far worse was to follow when the British Government announced deportation orders. These brave men, who had put their own lives on the line to help the British, now found themselves being thrown out of the very country they had aided. Rules stated that any man who was married to a British woman had the right to stay, but this was never explained to them. With no work they could not provide for their families, it was hopeless for them. The authorities fed them lies and at times basically threatened the men – anything to get them out of the country. Many men were put on to ships and deported, often without the knowledge of their families, who were left behind to wonder what had happened to their husbands and fathers. Sadly, some would never find out, while for others it would take many years to discover the truth. This was a truly shocking and terrible way to treat those who served our country so well

Liverpool is home to one of the oldest Chinese communities in Britain or Europe, with roots in the Frederick Street, Pitt Street and Cleveland Square areas. After the First World War, Dickenson Street, Kent Street, Greetham Street and Cornwallis Street became regular homes to the Chinese. Pitt Street itself by this time had no fewer than fourteen eating places, including five restaurants. Kwong Shang Lung had his grocer's at No. 12 Pitt Street. It specialised in Chinese food and was one of the first shops to be established within the vicinity.

The area was not just home to the Chinese community; it also housed Jewish, Dutch, Scandinavian, West Indian, Belgian, African, Russian, Indian and many other settlers. Seamen from around the world were attracted here when on leave. It may not have been the most affluent of places, but it thrived and bustled. Sadly, just as with the Irish and Italian communities to the north of the city, Chinatown was looked upon by some with distaste. The Liverpool City Council drew up plans in the 1930s to demolish most of the Chinatown and replace it with more modern buildings and tenement blocks. Their plans were helped along by the Second World War Blitz, which destroyed a large part of the area. We should never forget the part that Merchant Seamen from many nations played during the war.

The Second World War left a legacy of evil and hatred, as it showed how humans can treat one another. Targeting civilians, in my own opinion, is not war; it is murder and all sides were guilty of it. Again, we have to accept that it was a different world back then – one that many of us never knew. Yet the bombing campaigns against towns and cities, and the way that some people were treated, leaves a bitterness that is hard to shake. The Second World War gave us many lessons to learn, sadly today wars continue. We can never change the past, but we can remember; remembrance is everything.

GRANDAD

In a far off land, in Italian soil, lies a man
a soldier, a Scouser, my grandad, my hero
he died before I was born, sacrificed to war
yet our bond has strength, my love for him is endless
my pride, as always, overwhelming.

Lived off Scottie road did Grandad, Comus street
loved his mam Mary, his brothers John and Tommy
and his little sis Win.
His daddy died, shooting a big gun at Germans
in Belgium, in a field.

Grandad laid flags, Corpy paid him
worked at Spencer street.
you might have walked on his flags.

He met Nanna, and they fell in love
St Anthony's had a wedding
St Martin's cottages had new tenants
my dad was born, everyone happy, everything rosy.

Mr Hitler came along, everything bad, everyone sad.
Grandad called up, trained, kitted out, shipped off
they gave him a big gun, he shot planes, in Malta
three years later they said, 'Go home, have some leave'
put him on a ship to Nanna
and me dad.

Ship turned around, Sicily needs invading, no leave sorry
Sicily invaded, Italy needs invading, no leave sorry
we must get to Rome.

Grandad never got there
it was at Minturno, that they took him from Nanna
and me dad
my dad's daddy died, shooting a big gun at Germans
in Italy, in a field.

I went to visit grandad, in Italy, in a cemetery, not a field
I talked to him, I kissed his headstone
I cried.

My daddy died, he is with his daddy now, and his mam.
I miss him
My heroes are all together
in heaven, in a field, just having fun.

Anthony Hogan 2007

CHAPTER 7

THE ITALIAN COMMUNITY

During the 1870s and 1880s, many Italian families left their homeland to seek work and a stable future for their children. Disease and hunger had become widespread, food prices soared and unemployment rose. For many, the choice was simple; they could leave Italy or starve. Liverpool, with its busy port offering passage to America, was a popular choice. Those with enough money bought a passage here, others borrowed the money, the poor walked their way to Liverpool using their entertainment and working skills to earn money for food in towns and cities on the trek through Europe. Arriving in Liverpool, they would make for the area just outside the city centre heading north. Here, among the court and boarding houses, they knew they would receive a welcome, for one thing the Italians were certain to do was to look after their own. Welcoming houses would give them food and rest before either helping them find work and homes, or with purchasing tickets for the voyage to America. Through lack of money, fear of being turned away from America, or just their own choice, many Italian families decided to stay in Liverpool. Christian Street, Gerard Street, Hunter Street, Circus Street, Lionel Street, Grosvenor Street and the many smaller streets springing off them, this was Liverpool's Little Italy, home to not all, but the majority of Italians who chose to settle within the city. Living alongside them within this community were the Irish, with their Catholic faith helping them to form a mutual respect for each other. Many Italian/Irish marriages took place. St Joseph's church became the main place of worship for the Italians, though many chose Holy Cross church on the other side of Scotland Road.

The Italians were hard working, friendly and well liked within the community, finding success with business ventures. They brought with them their skills from their homeland, allowing them to maintain their own traditions as well as bringing them to the local people. They were wonderful entertainers, who brought their music, organ grinders, plaster figures, food and, with my eternal gratitude, their ice cream. They ran stores, cookhouses and fish and chip shops, while their skilled mosaic and terrazzo workers produced incredible work in some of the area's finest buildings. It is impossible to walk through Liverpool without seeing some of the skills of their craft. The Italians had settled in well in Merseyside, and although

the Little Italy area was one of the most impoverished areas in Liverpool, it did not deter them; this was their home. Like the Irish, they accepted what life had thrown at them, rose above it and got on with it all. Life could be hard and at times terrible, but they came through. The church processions and wedding celebrations have long since become legendary, most of us can only wonder at how marvellous they were, as we will never experience anything like them.

On 10 June 1940, Mussolini led Italy into the war when he sided with Germany, thus becoming an enemy of Britain and her allies. This decision triggered a number of events in Britain. Almost over night the orders came to round up Italians living here and have them questioned and interned. A list was already prepared for those deemed a risk to Britain's security. The story of their plight is often overlooked. A lot of those arrested in Merseyside were older men who had lived within the community for many years, many running businesses that served the local people. Some had sons serving with the British Forces, or had served for the British themselves during the First World War. None of this mattered. A lot of non-Italian locals were shocked at the treatment towards their friends and neighbours, who they knew to be good people and not a threat to anybody. Was it fair? No. But it was war, and sadly, war changes everything.

Like the German people living here during the First World War, the Italians soon experienced the dreaded early hours knock at their door as the authorities came looking for people to detain. As with the German's twenty-five years earlier, the Italian's often greeted the callers with the reply of, 'He is serving for the British at war.' The Little Italy area of Liverpool was a very close and tight-knit community. The powers that be knew this, and realised that they would face questions from the locals as to their treatment of the Italians, so they gave the dirty deed to the police force. The local bobbies, mostly from Rose Hill station, had the embarrassing task of knocking at homes and detaining people who they often knew very well and on friendly terms. Sadly, some frowned upon the Italians and were hell bent on causing them trouble. Italian-run shops and homes were attacked, windows smashed and insults thrown. Everyone had been living their lives together in Britain until the madness of war took over.

The detained Italians were taken to camps around the Lancashire area. Many were interned at the newly built housing estate of Woolfall Heath in Huyton. The estate became a camp in 1940 when the first internees arrived. Each house was meant to hold twelve people, but with so many arriving, tents had to be erected for use. The intention was to hold the men here until they could be moved to the Isle of Man, or, in other cases, further afield. Women were split from their men, families forced apart. They received no newspapers or reports about what was happening in the outside world and knew nothing of how their families were coping. Many women were left to bring up the children with the main breadwinner gone, unsure if he would ever return again.

Decisions had been made to deport many of the Italians to Canada or Australia. The cruise ships *Arandora Star* and *Ettrick* were used for the voyage to Canada. On 1 July 1940, the SS *Arandora Star* left Liverpool en route to St John's,

Newfoundland and the Canadian internment camps. Aboard were Italian and German British nationals and prisoners of war. Figures differ, but suggest that 734 Italians and 479 Germans sailed on the *Arandora*, along with eighty-six prisoners of war. The ship had sailed out of Liverpool with no escort and no Red Cross markings to show she was carrying civilians and prisoners. By the morning of 2nd July, she was sailing past the North-west coast of Ireland when she was spotted by the German U-boat U-47. At 6.58 a.m., a torpedo from the U-boat struck the *Arandora Star*, causing her power to fail. Her distress signal was picked up by Malin Head at 7.05 a.m., who in turn passed it on to Land's End and Portpatrick.

The ship was sinking fast and the crew tried desperately to launch the lifeboats, though many had been damaged by the explosion and others failed to launch. Those being held were kept in the lower levels of the ship, the Italians furthest down. They faced a tide of barbed wire to get up on deck, many of the British guards and German prisoners of war tried to pull the wire apart to help them, but time was running out and many would have sadly realised their fate. At 7.33 a.m., the ship sank. It is interesting that the captain of the SS *Arandora Star*, Edgar Wallace Moulton, had complained about the number of passengers and the amount of barbed wire used before sailing. He had asked for the numbers to be halved and the wire to be removed, stating, 'If anything happens to the ship that wire will obstruct passage to the boats and rafts. We shall be drowned like rats and the *Arandora Star* turned into a floating death-trap.' His protest fell on deaf ears and, sadly, his prediction was to come true. Moulton stayed aboard the ship trying to help the evacuation, he was aided by the German prisoner of war Captain Otto Burfeind. Both men perished.

A small flying boat, responding to the distress call, flew over the area and reported seeing people in the water. The HMCS *St Laurent*, a Canadian destroyer, arrived at the scene and picked up many of the survivors. The sick and wounded were taken to Mearnskirk Hospital in Scotland. The loss of life was terrible. It is believed that 486 Italians and 175 Germans died, along with British troops and crew. In the coming weeks the bodies of many of the victims began to wash up onto the shores of Scotland and Ireland. No complete list had been recorded for who was aboard; British troops had identity tags, but for the Italians and Germans it was a case of going through any personal belongings to identify them. One very moving outcome was how the people of the small coastal villages and towns of Scotland and Ireland treated the victims who were washed up on their shores. Although poor themselves and with no financial help, they paid for the burials and memorials to remember the dead of this tragic event. Humans being human.

Like many, the Italians living here gave so much to Britain during the war. Many of their men fought and died while serving the country that had become their home. After all the years, we can now look back on events and clearly see that they posed no threat and their treatment was harsh. Hindsight is a wonderful thing and a fear of the unknown can alter the attitude of the most placid person.

The Muscatelli and Vermiglio families were joined together by marriage in Liverpool. Their story during the war years is similar to that of many Italian

families living in Britain during these trying times. It stands as a reminder of just how much loyalty the Italians gave to their adopted homeland, and to the often harsh treatment they received from the authorities and those around them.

John James Muscatelli was born on 11 June 1920 to Fermo Carlo Muscatelli and Christina McLachlan. At the start of the Second World War, he joined up as a trooper with the 11th Hussars, Royal Armoured Corps. The address he gave upon joining up was No. 1A Queen Anne Place, Liverpool. John was sent to fight in Egypt and, while he was there, his father Fermo Carlo was interned in a Lancashire camp for being of Italian descent. He was classed as an alien and an enemy even though his own sons were serving for the British Army. On 29 June 1940, John was with his regiment's A squadron as part of patrols that were observing activities at El Gubi. They came under air attack and John attempted to tow away a damaged armoured car by hooking it to the lorry that he was driving. As he tried to flee, he came under further attack and was hit by shrapnel. They managed to get John away from the scene and took him to a military hospital. Sadly, at 4 a.m. on 1 July 1940, John passed away as a result of his wounds. Fermo Carlo was still in the internment camp when he received the news that his son had died while serving for the very Army that was holding him as a prisoner.

Josephine Vermiglio was a quiet girl who didn't go out very often as she was helping to look after the family home in Birchfield Street. Her parents were Dominic Vermiglio and Elizabeth Reid. One day a week she would go out to work in the canteen of the Art Quilt on the corner of Langsdale Street and Soho Street. Her sister Teresa and her husband Johnny Smith, local boxer Smiler Smith, talked her into going out with them to Rooney's pub one Sunday night. They told her that there was a smashing singer on there who sang with a band that did a few Italian songs, 'Sole Mio', 'Santa Lucia', 'Let Bygones Be Bygones' and a funny and naughty version of 'I'll join the Legion That's What I'll Do'. The singer was Austin Muscatelli, and the two of them hit it off, became close and were married on 17 March 1955 at St Francis Xavier church. They raised three children, Maria, Christopher and Austin. Dominic Vermiglio had boxed in Pudsey Street Stadium, and trained Dom Volante and Tommy Molloy. His sons gave shadow boxing and skipping exhibitions in the intervals at the stadium, and boxed for the Army. Many of their cups and trophies were on display in the family home.

Austin's mother Christina McLachlan was known as a lady with lovely ways and manners. His father Carlo Fermo Muscatelli came from Pontremoli in Tuscany. Pontremoli is in a municipality called Carrera, where they cut marble, including the marble used by Michaelangelo Buonorotti for the Statue of David. Carrera is also a paper making region, hence why Pontremoli is the place where they host the Italian equivalent of the Booker Prize, despite it being a small village. Austin's family were noted as having created a local confectionery sweet known as something like 'bone'. Fermo, or Carlo or Ted as he was mainly known, had jumped ship in Liverpool and worked on laying the terrazzo in the Liver Buildings and St George's Hall. He had also laid the doorways of Macy's department store in New York while he was in America.

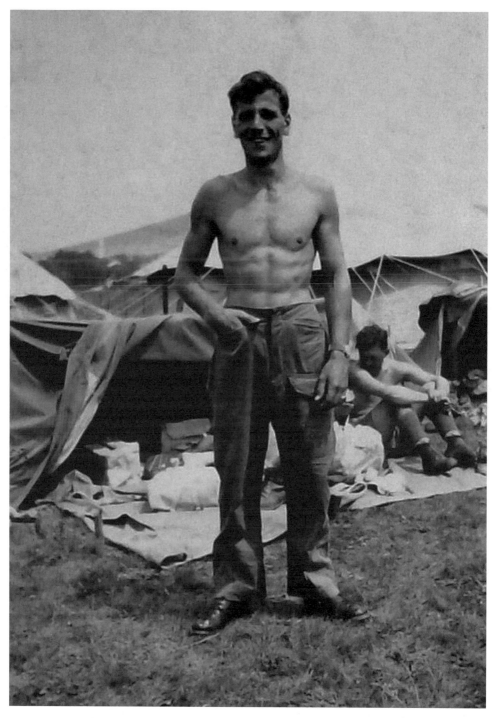

Austin Muscatelli serving during the Second World War. Notice his incredible six-pack.

Austin and Josephine Muscatelli.

In the Second World War, Austin joined the Royal Artillery. After doing his basic training in Carlisle, he returned home and found the words 'Mussolini's Bastards' scrawled on their tenement wall, despite the fact that he was serving, and his brother John James had died serving with the British Army. This was a cowardly act against a family who had given so much to serve their country. Austin fought in the North Africa campaign – Egypt, Tripoli, etc. – before fighting in Italy where he saw action at Monte Cassino. He was part of a gun crew on a 25-pounder, as well as being the P. T. Officer. After the war he joined the Merchant Navy, but

left because of hearing damage to his ears from the guns he used in the Second World War. He was totally deaf in one ear and forty-five per cent in the other, and would come home off leave from the Merchant Navy suffering bad pain from his ears. One time when Austin docked in New York, he took himself off to Macy's department store to see his father's terrazzo work in its doorway.

Josephine had five brothers serving for the British during the Second World War. The eldest, Albert Vermiglio, was shot in the leg during a shoot out with a German in a church in Italy. He was in a very bad way and his father Dominic borrowed money from his own brother Albert, so he could go and visit his son, who did survive his injuries. Albert, who accompanied Dominic to see his injured son, had his chippy window smashed in by a mob because he was Italian. He put a photo of his son Tom Vermiglio (later changed to Vernon) in his shop window in William Henry Street, with a sign that said, 'My son who was shot down in Germany and has been a POW for 4 years.' They never had any broken windows after that.

After leaving the Merchant Navy, Austin worked in The Clarence Dock Power Station as a stoker, and Josephine worked in her brother's general provisions shop. The power station was converted from coal to oil and all the over time stopped, so Josephine's brother Joe thought it would be a good idea for them to move above a new shop in William Henry Street, which he had had built as a chip shop, and for them to run it. The thinking was that they could make enough money from it to eventually be able to afford to buy a house of their own. It appeared to be a thriving business with the local clientele in the four squares and the Heights Canterbury, Crosby and Haigh, but, as it happened, later on they were all demolished and Austin and Josephine never did buy that house. In 1983, they retired and moved into a lovely flat in Fazakerley.

CHAPTER 8

SAMUEL SPEARS

Samuel Spears was born on 29 November 1919 in Liverpool to Samuel Spears and Annie Stanley. His mother died when he was ten, and his older sister Annie raised her siblings and kept them all together. Samuel joined the Royal Air Force in the Second World War, being sent to serve in Singapore. By 1942, he was Cpl 547066. Early in 1942, panic broke out in Singapore with the realisation that the Japanese forces were heading their way, and that the allies in the area were under numbered to fight the huge army that was coming. The Keppel Harbour was full of ships and boats trying to evacuate people; women, children and servicemen all clambered for a space aboard anything that would ferry them away. Some made it to safety in Australia, while many were put ashore on the islands of Jave and Sumatra. Singapore fell on 15 February and the Japanese then began their search for the escapees.

One British officer, Capt. Dudley Apthorpe of the Royal Norfolk Regiment, had managed to make it to Padang in Sumatra. On arrival he realised that the last of the rescue boats had departed. He waited until darkness had fallen before searching for anything he could try and escape on. While doing so he met up with a number of other men who had the same idea – four Army officers, thirteen soldiers, three Navy men and Captain Apthorpe made them a group of twenty-one. They set about looking for a vessel that they could use, eventually locating a 50-foot Japanese sailing boat with the name *Bintang Dua*. Finding a map on board the boat, they realised that the island of Siberut was their only navigational guide and decided to head towards it. Not long after sailing out of Padang, they came across a small boat holding eight other escapees, who they helped aboard. Among them was Samuel Spears, who had managed to make it to Sumatra before crossing the island to Padang. The total on board the *Bintang Dua* now came to twenty-nine as they set out on their bid for freedom.

The Island of Java fell into Japanese hands on 8 March, and any escapees who had fled here were taken prisoner. The Japanese now set their sights on taking Sumatra. Doing so with swiftness, they took control of the island on 17 March. They had ordered patrol boats to go out and hunt down the escapers, but this task was proving a nuisance to the Japanese generals, who had strict orders to

comply with. The escapees were hampering them and they now decided that enough was enough. Samuel and the other men aboard the *Bintang Dua* had managed to remain at sea undetected for over two weeks. Their luck, however, was about to run out. On the same day that Sumatra fell, they were spotted by a Japanese patrol boat and towed back to the small island of Siberut. Once here, they were informed that they would be taken to Padang in Sumatra, where they would all be executed. The Japanese were getting tough on escapees. We can only imagine their thoughts as they sailed across to Padang, their fear as they realised that death was coming.

When Samuel and the other prisoners of war arrived in Padang, they found the Japanese busy gathering prisoners for transportation to Burma, where they were to be used to build a railway line from Thanbyuzayat that would eventually be linked up to Bangkok in Thailand. The need for workers saved them from execution and they became part of a mixed group of British servicemen who numbered around 1,200. These prisoners of war were known as British Battalion or the Sumatra Battalion during their captivity, their leader being Capt. Apthorpe.

The Japanese thought little about taking care of the prisoners, at first placing them in a Dutch barracks, where Chinese people were brought in to cook food and told to charge the men themselves for it. On 9 May 1942, the prisoners were told to assemble 500 men on the parade ground. The Brits, being Brits, did this in an organised fashion, selecting 20 officers and 480 other ranks for inspection, Samuel Spears being one of them. The Japanese showed no interest in the British waiting inspection, simply stating that they needed 500 bodies for movement to another camp. No information of where they were going was given.

They were put on a train for a journey of around 100 miles through the Sumatra Hills, moving into lorries when the train stopped, before sleeping the night in an empty convent. The following morning they were given a tiny breakfast, then loaded into lorries again for a 12-hour journey through the Sumatra mountains and jungle. The men slept that night in an old school building at Kata Nopan, the next day being much of the same before that night bedding down in the Tarotoong market place. Their fourth day, 12 May, was again a long journey in the lorries with hardly any food, passing near Medan before arriving at the port of Belawin Deli that evening. From here, they were marched to a Dutch internment camp named Uni Kampong. Conditions were terrible, but the civilians who were housed there shared their food and clothes with the men in a wonderful gesture of kindness.

On 15 May, they were marched to the harbour along with a number of Dutch prisoners of war, and put aboard a ship called *England Maru*. It was pretty grim with the men being packed in the hellish ship; small shelves had been erected that just about allowed a man to lie down. Nothing was there for the men to wash with, and only a few were allowed up on deck at a time for fresh air. The food served to them amounted to a small quantity of rice with vegetable water. They waited the whole day on Belawin Deli Harbour until they were joined by a number of ships holding Australian prisoners of war. The convoy then set sail up the Malacca Straits and on towards Mergui in Burma, arriving on 25 May.

The men had endured an awful sea journey. On their arrival, they marched to the Mergui National High School under heavy rain. Food rations were very poor at the camp and the men had to prepare it themselves. They rested for two days before work parties were ordered to enlarge the aerodrome and over half of the men were put to work. The Japanese paid the men a tiny amount of money that could be spent inside their camp with a Burmese trader; a few bananas or a small bit of tobacco was all they could purchase. The men suspected that this was only being allowed as the Japanese were making a profit from it, which was later proved to be correct.

One Japanese sergeant along with thirty soldiers was considered enough to guard the prisoners. The guards cared little for their welfare, conditions or food rations; all they cared about was work parties. The prisoners, however, decided to do as little work as possible, disobeying the rules whenever they could. After constant complaints to the Japanese about the terrible conditions at the National High School, they were moved to a new camp on 21 June. The huts were just made out of wood and bamboo, but the men had more room, plus locals brought goods into the camp for the men to purchase.

Samuel remained in this camp until 10 August, when a parade was ordered by the Japanese and each prisoner of war was given a numbered disc. The men then marched to the landing stage, where they were boarded onto another hellish ship named *Tatu Maru*. It was by now pouring with rain and the ship had been crammed full of men, leaving many more to suffer the conditions up on deck. They sailed at 1 a.m. on the morning of the 13th, arriving that evening at the mouth of the Tavoy River, before being transferred by barge to shore at Tavoy. Their new camp gave them a bit more freedom. Working parties were still ordered for the aerodrome and in the town, but they had access to a lot more essentials. An Indian-Burmese resistance movement had been started and they managed to supply the prisoners of war sent to work in the town with basic medical items, food, and money.

On 21 October, they were paraded, issued with number tags and moved to the river's mouth to board yet another hellish ship. They arrived in Moulmein, Burma before marching to the local prison. Along the way, a crowd of Burmese people came up with fruit and food, and although the Japanese guards tried to push them away, they managed to pass a lot of it on to the men. Samuel found himself locked inside the prison overnight, still with no idea as to what was going to happen. The next morning they were marched to a railway station, where they were crowded into cattle trucks for the 30-mile journey to Thanbyuzayat. They were about to start the horrendous work on the Burma railway known as the Death Railway. The railway was to be built on two sides from Thanbyuzayat/Burma and Siam/Thailand; the Three Pagoda Pass was to be the joining up point. Camps were erected at 5 kilometre intervals – 1 Kilo camp being 5 kilometres from the start of the railway, 2 kilo being 10 kilometres, etc. The work parties were known as *kumies* by the Japanese.

After three days, Samuel and the battalion were moved to the 18 Kilo camp at

Hlepauk. The camps all tended to be alike, a summary of one gives an idea of what they consisted of. Built alongside the railway, the camps would be formed around an open square. Bamboo huts with palm leave roofs sat at one end to house the prisoners, while solid built wooden huts housed the Japanese at the other end. A cookhouse would sit in one corner, while a guard hut and gate markers made up the remainder of the camp. No fence was constructed or needed, for the Japanese knew that 800 miles of jungle was a very good deterrent to any man. The prisoners needed to make their own washing, cleaning and toilet facilities, with nearby streams being their source of water.

This was the life that Samuel was now forced into: put to work early, a 2-hour break at mid-day, back to work until 8 p.m., wash in the stream, back to camp. As long as the work was deemed to be done, then the Japanese guards cared little what the prisoners did. The men themselves supplemented their meagre rations with what they could buy or find, lighting fires of an evening to cook whatever they had; small amounts of tea, coffee, eggs and tobacco could be purchased within the camp. The Japanese tried to make as many men as possible work on the railway, while the prisoners tried everything to get as many as they could in the sick bay. Despite a bit of tit for tat from both sides, within weeks of arriving in Hlepauk, Korean guards replaced the Japanese and were more strict and brutal.

On 3 January 1943 they were loaded into lorries and transferred to the 35 Kilo camp at Tahyin, staying here until 20 March when they moved back along the line to Thetkaw and 14 Kilo camp, before again moving on 5 April to 25 Kilo camp, Kun Knit Kway. On 26 April they were again on the move, this time to Ansakwin 45 Kilo camp. The work was now becoming tougher as the Japanese upped the rate. Previously, the men had laid rails and built embankments. Now they had to unload everything – rails sleepers, tools, food and medical supplies. The work was now 24 hours a day, with the men working 8-hour shifts. As the pressure took hold and some fell sick, the shifts were increased to 12 hours. Life was getting much harder for Samuel.

The rain now arrived, and with it came sickness, yet the workload never ceased. Many men fell ill, the death rate rose and the rations remained too small, yet the Japanese still wanted more from the men on the railway. Samuel and his comrades were moved up and down the line at Taungzan and Apalon as the year went on, before they arrived at 114 Kilo camp in Chaungera, Thailand on 14 November. This was their grimmest camp yet. The huts in the camp were falling to bits, many had no roofs; the men were sick and there was little hope of the Japanese getting any work parties out onto the railway. The rations for the men were reduced to basically nothing, and the monsoon was making conditions more severe. It was so bad that, on 11 January 1944, the Japanese decided that enough was enough and moved the men to Kanchanburi. Thirty-nine men of the British Sumatra battalion died while at Chaungera.

They moved on 23 March 1944 to Tamarkan. Here, the men who had been together throughout all of this were split up and the Sumatra battalion was

no more. Around 200 men remained in Kanchanburi; most were sick, with the others comprising of those still at work on the railway. The remainder were to be transported to Japan to be used as labour. Those going to Japan became known as the 51 Kumi. Samuel Spears was not with them, he was one of those left behind. The men in the hospital camps were now forced to work on the Tavoy Road. It was brutal and caused many deaths. Samuel was among all this horror and hopelessness; we can only wonder what he was feeling, his body was deteriorating, his mind must have been half insane – did he believe he would die in the jungle?

However bad the Japanese treated the men, signs of hope began to emerge. The men started to notice regular allied bombers flying over and news was reaching them through smuggled newspapers, makeshift radios and local people informing them of how the war was turning in their favour. The war was entering its final phase. Could the men hang on to their survival? They did not know it at the time, but the Japanese guards had received orders to kill any prisoners if the allies came. The allies did come; the Japanese were pushed back, defeat after defeat left them in no doubt that their war was finished. Samuel and the men were liberated while in camps along the Tavoy Road. The guards fled instead of killing them. Freedom had come, but at a price.

Starvation and malnutrition had taken its toll on the men, and flies and lice had made disease rife. Add the severe work that was forced upon these men and you wonder how anyone survived. There was also the brutality that the men had had to endure from slaps in the face and hits by rifle butts, along with beatings by the guards, often handed out for little reason. Punishments were handed out where men would have to stand with a bucket of water on their head or were forced to run on the spot for hours in the blazing sun. Often men were locked in tiny cells with no food or water. A lot of men were executed in front of their fellow prisoners of war for stealing food or trying to escape; war tribunals afterwards were filled with many of these stories.

It was appalling how the men were treated. As the war drew on, shortages grew in Japan, so the men received less food, clothes and medical supplies. When they were liberated, despite the fact that most of the men were walking skeletons dressed in rags, they had somehow built a railway. Over 150 men from the British Sumatra Battalion died during their time in Burma and Thailand, and over ten percent of all British prisoners of war died while working along the Death Railway. Thanbyuzayat, Kanchanaburi and Chungkai now house cemeteries for the victims, while memorials in Singapore and Rangoon list and remember those who have no known grave.

Samuel Spears returned to Liverpool, where he was nursed for a while by his sister Annie, who had to feed him mashed up potato with milk from a saucer. He was in a terrible condition, yet gradually he became stronger and was able to cope more. The body may heal but the mind retains everything, and Samuel had his nightmares, often waking screaming from his dreams. In 1947 he married Mary Regan and they raised a family of four children. Samuel passed away in April 1998

aged seventy-eight. To survive all that he did, basically torture by the Japanese, then to return home and carry on, hold down a job and raise a family, all with the horrors inside his head. You just have to have total respect for Samuel and the others like him who endured so much.

CHAPTER 9

THE BLITZ

The bombing of civilians is pure evil; there is no other way to describe it. During the Second World War it became a weapon for all sides as they tried to frighten, kill and demoralize the population of towns and cities. Britain was to feel the full force of the Blitz, with its major cities, shipyards and industrial areas coming under fierce attack, yet she and her allies would strike back with devastating effect. In August 1940, a number of bombs fell in London. The following day, the RAF bombed Berlin, and so began a tit for tat campaign of terror. In one speech, Hitler said, 'We will raze their cities to the ground. One of us will break, and it will not be the National Socialist Germany.' These early raids would grow in size over the next few years as both sides advanced their technology, culminating in the dreadful and controversial firestorm bombing of Dresden in February 1945. London, Hamburg, Glasgow, Berlin, Coventry, Cologne, Newcastle, Munich, Manchester, Dusseldorf – the list goes on. It spread across Europe and further afield, resulting in the deaths of thousands of men, women and children.

Liverpool and Birkenhead sit opposite one another on either side of the River Mersey; Liverpool with its almost 8 miles of docklands, and Birkenhead the former home to the Cammell Laird shipbuilding company. During the Second World War they were both a hive of activity, as huge quantities of shipping entered and left the river. Troopships, warships and submarines all came and went, while the Merchant Navy supplied Britain with much needed materials and food, suffering terrible losses in the process. Of course all of this had made the area a prime target, the Germans had done their intelligence work and the orders were given to attack and destroy. On the night of 9/10 August 1940, the bombers came. Birkenhead and Wallasey took the hit, a week later Liverpool was to feel its first full attack. The bombing continued night after night – nowhere was safe, the suburbs as well as the docklands and shipyards were hit, buildings and factories, houses and streets – all were slowly being reduced to rubble. This was now a way of life for the people of Merseyside as raid after raid came, no place was spared. It would need far more than one chapter for me to cover all the raids, so I have chosen to include a small section that will stand as a reminder to all those who died.

The Ernest Brown Junior Instructional Centre, off Durning Road in Edge Hill, was chosen as the site for an air-raid shelter during the Second World War. Its

basement and in particular its boiler room, with its reinforced ceiling, offered protection to the public from the enemy bombs. On the evening of 28 November 1940, the warning was given and local people started making their way towards the shelter. Men, women and children dressed warmly and mothers wrapped their babies in blankets to protect from the cold night. Two trams stopped outside the building and the passengers joined those already inside the shelter. In all, over 300 people entered the basement as the bombs began to fall. At around 1.55 a.m. on 29 November, the school took a direct hit from a parachute mine. The building collapsed, sending debris straight onto those sheltering in the basement, and many people were buried alive. The boiler burst, streaming out hot water, and burst gas pipes alighted. Anyone not killed outright now faced these horrific dangers. Up above, the building was ablaze and rescue workers struggled to help free the survivors. During the next two days the rescue effort went on as first the survivors and then the bodies of the dead were brought to the surface. It became clear that retrieving all the bodies was hopeless, so the call was made to cover the area in lime and seal it over. Just as work was about to begin a fireman noticed a hand coming from the rubble, and a twelve-year-old girl became the last survivor to be saved. The area was then limed and sealed, thus becoming a grave to those that remained.

Police figures gave the total number of dead as 166, however, it is widely believed that the figure was much bigger at around 180. Of the survivors only thirty people escaped unharmed. Many spoke of having to walk over dead bodies to escape. Many of the dead remained unidentified and were buried together in a grave at Anfield Cemetery. Winston Churchill described the bombing as, 'The single worst civilian incident of the war.' The tragedy left a lasting impression on the local community, with the event becoming known as The Durning Road Bombing. A local man who was a serving soldier was home on leave at the time of the bombing. He helped during the rescue operation and he himself brought three children from the ruins. Because he had stayed to help, he had outstayed his leave and on returning to his regiment he was charged with being AWOL. He was found guilty and served time in a military prison as a punishment.

During the evening of 20 December 1940, the air-raid sirens rang out to warn Liverpool's people of the approach of the German Luftwaffe. The tenements of Blackstock Gardens off Vauxhall Road housed a large concrete shelter within its grounds. Locals from the gardens and the area made their way there, and two trams also stopped here to allow their passengers to escape the bombing. The shelter became so crowded that people were turned away and had to find refuge elsewhere, while a number of residents of Blackstock Gardens decided to stay inside their homes during the raid. The shelter, which was situated in the centre of the tenements, took a direct hit and bore the brunt of the blast, with the shock waves blowing into the surrounding homes. It caused utter carnage and destruction, with rescue workers facing a grim task as they attempted to help the wounded. Reports list the number of dead as up to 200, though records link 72 casualties to the Blackstock Gardens bombing. Allowing for the number of unidentified deaths

The steel unit seen beyond the Eagle Pub is on the former site of Blackstock Gardens.

and those that occurred within the immediate area that night during the fierce bombardment, the Blackstock deaths could well reach up to and past 200.

Billy Bellis had gone into the shelter with his mother Sarah; sisters Catherine, fourteen, Joan, seven, and Patricia, four; twins Robert and Cecilia, three; and baby Edward aged six months. Billy was the only one to survive. He had gone to play with a friend at the other end of the shelter when the bomb hit; he became trapped under rubble and was pulled out by his father William, who had come to search for his family. Joseph and Anne Fitzpatrick lost three of their children in the shelter, Marie, eight; Christopher, six; and three-year-old Eileen. Elizabeth Flynn died along with her children – Christopher, eleven; Eleanor, three and fourteen-month-old Gerard. Their father Thomas was away serving with the Royal Artillery. William and Annie McGuigan died in the shelter with their eleven-month-old daughter Margaret. Rose Ann Toner, aged twenty, died alongside her three-year-old son John. Her husband John was serving with the Royal Artillery. Ellen Twigg and four of her children – Ellen, eight; Teresa, seven; John, three; and Robert, eighteen months – were also victims of the shelter bombing. Ellen's husband John was away serving with the King's Own Regiment (Liverpool). Mary Ellen Tynan was killed with her son John, seventeen, and daughter Rose Cecilia, fourteen. Ellen Melia was

On Vauxhall Road stands this memorial to the victims of the Blackstock Gardens bombing.

rescued, but passed away the next day at the Mill Road Infirmary. Her children, John, ten, Mary, eight, and Joseph, six, died in the shelter. John Clark had remained in his home at No. 6a Blackstock Gardens with his children Mary, twenty-two; Elizabeth Janet, sixteen; and William, thirteen. They were all killed by the blast.

At the top of Bentinck Street, off Great Howard Street in Vauxhall, stood a set of railway arches that were being used by people living close by as a shelter from the bombing raids. It was an unofficial shelter that the locals believed would offer them protection as the arches below the railway line were strong. On the night of 20 December, the alarms went up and people crowded into the arches. Sadly the shelter took a direct hit, resulting in its collapse. Many people were trapped beneath the rubble and concrete blocks that had fallen, leaving the rescue workers

Looking along Bentinck Street with the warehouses to the right that were here during the time of the bombing. The buildings on the left-hand side are where the houses stood and, of course, where a number of the victims lived. The railway arches can be seen at the top of the photograph.

with a difficult task in helping the survivors. One newspaper reported forty-two people as losing their lives in the shelter bombing; at least twenty-eight are recorded in official records. It is believed that a man survived the Bentinck Street Bombing when his wife realised she'd forgotten the baby's bottle and he went back for it.

Ellen Fitzpatrick had taken her family into the shelter when the alarms went off; her husband Philip was working on the nearby docks, and their oldest child, Catherine, aged seventeen, was working elsewhere. While in the shelter, Ellen decided to send her son Jimmy back to their home on an errand. Jimmy left the shelter and ran the short distance to their house at No. 12 Idris Street to make a pot of tea and fetch a loaf of bread. As he was making the tea he heard the explosion – his mother's errand had saved his life. Philip and Catherine returned from their jobs to discover the tragedy that they and young Jimmy were the only members of the family left alive. Phillip's wife, Ellen, had died in the blast alongside her children – John, eleven; Phillip, nine; Bernard, seven; Edward, five; Ellen, three; and Ann, aged one. The Fitzpatrick grave in Ford Cemetery holds the names of all family members who died in the bombing. Philip, Catherine and Jimmy have also been added over the years – they remain together. Also killed in the shelter were Julia Chew and her twenty-month-old son Michael (her husband Joseph was serving overseas); Elizabeth Cox and her two-month-old daughter Mary; Terence Mooney and his two daughters – Mary, sixteen and Ann, five – and husband and wife John and Alice Hannaway, both aged sixty-three. Thomas and Ellen Kavanagh had gone to the shelter from their home at No. 4 Paget Street and died along with their children – Thomas, four, and James, two. A firm located within the arches in the 1960s had a worker claiming that they could hear scratching coming from the inside of the arches, which was now a type of lock-up. Rats were ruled out as the room turned out to be empty when they looked inside. Loud singing was also heard, described as being like a party, but upon checking the room it was again found to be empty. A man who worked there said, 'Of course, they used to sing in the air-raid shelters.'

The bombers returned on the night of 12/13 March, with heavy attacks on Liverpool city centre that caused damage in Victoria Street, South John Street, Dale Street and to many buildings. Wallasey also fell victim this night. In Birkenhead, Carnforth Street was hit with the loss of at least six lives, while shops on nearby Oxton Road suffered huge damage. Around twenty people died during explosions in Laird Street, while Birkenhead Park Station, Brattan Road, Duke Street and Bidston Road all suffered from the raids. Church Street in Wallasey was so destroyed that most of the properties had to be demolished. An air-raid shelter in Adlington Street off Byrom Street in Liverpool took a full blast, leaving many dead and injured, while houses behind the shelter in Lace Street felt the full impact. Rescuers had to pull at the rubble with their bare hands to try and get to those trapped inside. As they did, an enemy plane swooped down and began to spray them with machine-gun bullets. At least sixty-five people were killed in this tragedy, with some reports putting the total death toll at 125.

Bentinck Street. You can see the arches that were used as a shelter behind the fencing. Note the train going across them.

Maureen Kilbride (née Flaherty) was just five weeks old when her home in Lace Street was bombed. Her family, in a state of shock, surveyed the scene and found that the stairs of their tenement block had gone. With no idea if the building was in danger of collapse, they knew they had to escape – the only way out was through the window. Maureen was thrown to safety, being caught by a priest from nearby Holy Cross church. The remainder of the family managed to climb down, but once on the ground they realised that two of the children – Frank and Veronica – were missing. To Maureen's mother's horror, her husband had ventured back into the building unaware of his missing children. He returned with the family canary and a quantity of sausage, only to find his wife screaming at him to get out. Frank and Veronica had been buried under rubble. Frank was found quickly, but it took a few days to locate Veronica, who turned out to be fine. Maureen's mother Sarah had two very good friends who died that night – Rooney Neary and Charlotte

Gerrard. Sarah lived at No. 1a Lace Street, which was at the other end of the landing from where Charlotte lived. Charlotte's husband Michael had been killed just before Christmas 1940, while serving in the Merchant Navy aboard The SS *Napier Star*. Charlotte died alongside her son Michael, while Rooney and eight of her children were killed in the bombing. Sarah's nine-year-old daughter Mary used to sleep in Charlotte Gerrard's flat every night to keep her and her children company and help out, but on this particular night she told her mam that she did not want to sleep there, and could not be coaxed to go no matter what was said to her. In the end Charlotte told Sarah to leave Mary be if she was afraid and she went home. If Mary had stayed with Charlotte that night, her family would never have seen her again.

One of the most remarkable stories anywhere during the raids on the UK happened at Lancaster Avenue in Wallasey on 16 March 1941. Workmen were busy clearing the street of rubble from the bombings on the 12th when they heard what they thought was the cries of a kitten. In silence they listened once more, and realised it was not a kitten but the cries of a baby. At once they went to work, clearing the debris as carefully as they could, making sure nothing fell and hurt the child. After a short while they managed to reach the baby girl, named Irene Foulds, and brought her to safety. She was covered in dust and had lay there for almost four days, yet she was fine and well after her ordeal. Sadly she lost her parents in the raid. The bombing at Lancaster Street had cost over thirty lives, including four members of the Bennion Family at No. 54, and three members of the Dawson family at No. 52.

Just before 11 p.m. on 1 May, the first set of bombs fell on Wallasey and signalled the start of the May Blitz. What followed was eight days of madness and terror that were aimed at crippling the ports either side of the River Mersey, and hampering the supply lines from the West. The area was hit hard during this period, with terrible loss of life and destruction. That first night of raids saw damage in Cazneau Street and Low Hill, while Garmoyle Road and Wellington Road had houses demolished. The glass roof of Lime Street railway station was damaged, and Crawford's biscuit factory was hit, causing a fire, before bad weather forced the Luftwaffe to return to its base. Nobody could have known just what the next few days would bring when the enemy came back. Friday 2 May and Saturday 3 May will always be remembered as the biggest night of terror ever to hit the Merseyside area, as the bombers returned in force with wave after wave in a prolonged attack. Relentless bombing reduced many areas to rubble and hundreds of buildings stood burning. Reports estimate that up to 500 enemy aircraft pounded the area for seven hours. Yet the people stood strong and saw it through, their determination and strength is worthy of our admiration.

Many people had made their way into the shelter on Queen's Drive in the Broadgreen area as the heavy bombing raid took hold. A number of them had come out of a local dance hall looking for shelter as the sirens rang. Four young ladies had gone into the shelter, but after looking in they decided not to stay there, as they knew of another shelter where there was always a good sing-song. These

ladies had a lucky escape, for the shelter later took a direct hit that left at least twenty-nine dead and many more injured. Those who died included firewatcher James Yates, his wife Annie, and their children – James, eleven, Margery, eight and Mabel, aged eighteen months. The family had resided at nearby No. 7 Statton Road with Annie's parents Sarah and Timothy Lucas, who also died in the shelter. Their neighbours, Thomas and Matilda Thomasen of No. 10 Statton Road, were also killed, along with their children – Thomas, twelve, Matilda, eight, Ivy, seven and Andrea, six.

Holy Cross church stood on Standish Street with the huge presbytery attached to it on Great Crosshall Street. The school was located in nearby Addison Street, and was used as an air-raid shelter where people would go into the basement of either the boys' or girls' buildings for safety. Both the church and school suffered terrible damage when they were hit by parachute mines, and the rescuers who came to help were greeted by total carnage. The girls' building remained untouched, but

Queen's Drive with the junction of Edge Lane. The land is where the Rocket Shelter stood.

the boys' building was now a mixture of rubble that was sitting on top of the shelter. People rushed to help, digging with their bare hands in an attempt to reach those trapped below, efforts that no doubt saved many lives. At least seventy-two people died in the shelter, many from the same families.

Elizabeth Clarke of No. 90 Bispham Street was killed, along with her children – Edward, eighteen, Rose, sixteen, Catherine, fifteen, twins Richard and Ellen, ten, and James, eight. Ellen Clayton of No. 40 Bispham Street died with her daughters Mary, six and Catherine, three. Lilian Finnigan, who resided at No. 58 Bispham Street, and her children – Christina, seventeen, Michael, sixteen, Lilian, fourteen and Margaret, twelve – were all victims. So were Catherine and James Edwards, who came from No. 20 Bispham Street, and their children James, eight, Teresa, five and two-month-old Esther. At No. 78 Bispham Street lived John and Mary Forrester,

Holy Cross Memorial Garden located in Standish Street. Inside the glass case is the Pieta Statue that once stood inside the church. The garden contains memorials to men of the parish who died in both world wars, and those who perished in the bombing raids.

who died in the shelter with their children – Margaret, twelve; Thomas, ten; Ann, seven; Mary, four; James, three; Sheila, two; and Terence, two months. Another Bipsham Street family from No. 70 were Francis and Emily Flynn. They were killed along with their children – Francis, six, Elizabeth, four, and eleven-month-old John. Mary and Robert Ireland, who lived at No. 19 Bispham Street, died in the shelter alongside their children – Peter, fourteen, Rosemary, twelve, Mary, ten, and Robert, eight. Annie and James McNab of No. 14 Addison Street were killed with their son Peter, aged three. Mary Fitzgerald, who lived at No. 61 Midghall Street, died with her daughters, Mary, eighteen, and Eileen, sixteen. Both the church and school were demolished and later rebuilt; the second church was demolished in 2004.

Mill Road Hospital played its part during the Liverpool Blitz, helping to treat the injured from bombing raids across the city. On 3 May 1941, the hospital itself

Looking across the memorial garden. The apartments in the background are where the church and presbytery once stood.

fell victim to the German bombs, leading to large loss of life in one of the saddest chapters of the Second World War bombings. The bomb that hit caused total devastation when it landed in a courtyard to the rear of the hospital; a maternity ward was hit, killing mothers and their newborn babies. Amazingly, the ward next to the maternity was full of injured soldiers, yet they received no wounds from the blast. Many drivers died in the ambulance room that was in the courtyard and many ambulances and other vehicles in the area were set alight. A number of medics operating on a man were also killed, while the man himself survived. A nurse attending the operation had to scramble through a window to raise the alarm. Three of the ward blocks were totally destroyed, and the rescue workers faced a daunting task with so many people trapped beneath the debris and, to add to their struggle, bombs kept falling nearby, making the rescue even more dangerous. They risked so much to help and are the unsung heroes. A lot of

Two posts on Mill Lane that were part of the hospital. Both posts have walls running off them that act as garden walls to the new houses. The hospital was demolished and, in recent years, new housing has been built upon the land, making it impossible to take any kind of photograph to explain what was here.

unaffected patients were moved out to other hospitals as the rescue took hold, the building being too unsafe for them to stay there. Those injured in the blast were helped and if possible transferred elsewhere for treatment. Then the grim task of bringing out the dead was undertaken, hampered by the debris and fires. It became clear that a few of the bodies could not be recovered, so soldiers were brought in to lime over and cement the area. What the rescue workers witnessed must have stayed with them forever.

The number of people killed in the bombing will probably never be known. Mill Road was a working hospital that received a large amount of casualties from raids across the city. It was hit during the Liverpool May Blitz, one of the most fierce and continuous attacks upon the city. Victims may have died at the hospital this night from injuries received elsewhere, or from the explosions that rocked the hospital, but we have no way of telling how each person's death was caused. Records list at least seventy-eight people who died as a result of the bombing at the hospital; the true figure, however, will be much higher. The hospital superintendent, Leonard Findlay, received the George Medal for the bravery he showed on this night. Matron Gertrude Riding had refused treatment to her own eye wound, and kept on helping those who were injured. Her injury resulted in the loss of her eye. Gertrude was later awarded the OBE, not only for her actions on this night but also for her service throughout the war.

The aftermath of the Mill Road bombing was beyond sadness – so many dead and injured, so many young babies and children. Among those killed were nineteen-year-old new mum Joyce Bell and her one-week-old daughter Susan; Amy Davies with her son of one day Brian; Edith Foy and one-day-old son Lawrence, whose husband and father Lawrence Foy was serving with the Pioneer Corps; Grace Knox along with her one-week-old son Hugh; Elizabeth Lilley, who died alongside her eighteen-month-old son Lawrence; Norah O'Brien with her son of three days John; two-day-old Joan Raffertey and her mother Alice; and Margaret Thompson and four-day-old daughter Brenda. One name in the death records brings an instant tear to the eye; it reads 'Baby Connor, aged 2 days'.

During the night 7/8 May, locals made their way to the shelter at the Co-operative store on Stanley Road in Bootle. It was the basement of the building that was being used as a shelter, with people using the entrance of the billiard hall next door to the Co-op to gain access. The billiard hall was on the corner of Stanley Road and Ash Street; you went in through the billiard hall doors and down steps into a space that branched off into tunnels. Families would go into the shelter with bedding, food and drinks. Some people would bring a mouth organ, a banjo or an accordion, and they would have sing-songs or the children would do a party piece – anything to entertain. Then they would go off to sleep while the women sat and knitted, or chatted. The shelter was full of people when the bombs arrived. High explosives hit the building, blowing out the front wall. This led to the floors collapsing down onto the people sheltering in the basement. Many survivors climbed through the emergency escape hatches that were in place around the shelter's perimeter. It is also believed that some people made their escape by going along the tunnels that led

to Little Strand Road opposite. Rescuers fought to save those injured and trapped before the grim task of retrieving the dead began. The bodies were removed and placed in the temporary mortuary in the gymnasium at the Marsh Lane Baths. The following night, the mortuary received a direct hit from incendiary bombs. At the time it held 180 corpses awaiting burial and, of these, forty still had not been identified, including a number from the Co-op shelter. The gymnasium building was raised to the ground by fire and the remains of the bodies were collected and buried in a communal grave at Bootle Cemetery.

Records list thirty-six people who died as a result of the Co-op bombing. The total number of dead will never be known, however, due to those who were unidentified. Among those killed were John and Henrietta Austin of No. 79 Litherland Road; Albert Ney and his daughter Yvonne, aged nine, of No. 47 Cedar Street; David and Margaret Ratcliffe of No. 182 Peel Road; Sarah and Charles Hazlett of No. 136 Strand Road; and Francis and Cecelia Kirby of No. 254 Strand Road. In 1988, a memorial garden in Ash Street was opened, with a plaque erected to remember those who died in the Co-op bombing. The garden was refurbished and the plaque restored in 2009.

This night brought to an end the May Blitz of 1941. Though the bombing would continue, it would never be as ferocious as these last eight days. Locals would describe this time as '8 Days of Hell'. Hitler now moved most of his air force to the east to concentrate on the attack on Russia, his attempt to destroy and cripple the ports either side of the River Mersey had failed. Liverpool, Bootle, Wallesey, Birkenhead and the surrounding areas lay in ruins, but the people's spirit was unbroken. It was they who carried and kept everything going, allowing the country to keep on being supplied. Lest we ever forget their heroism and sacrifice.

The Blitz also brought moments of comedy, such as the lady with the shiny step in the Wavertree area. The women would take huge pride in how clean the steps to their homes were; this particular lady had a step that gleamed, and although a little wonky, it was her pride and joy. Many years after the war workman who were working on her house noticed the step and rang the police, who in turn rang the Army who sent a bomb squad. The step was in fact an unexploded bomb from the Blitz that had somehow lodged into the front door steps. It was removed and the steps were mended, probably much to the annoyance of this proud lady. Elizabeth Flemming was in a shelter when the doors got bombed open and she ended up losing a leg. Some time later a car knocked her down and the driver thought he'd cut her leg off, as it went flying through the air; the poor man almost fainted.

In Birkenhead, Ford Road, Manor Drive, Manor Road, Beryl Road and Rydal Avenue took hits on the night of 28 May. Two days later, Church Road, Houghton Road, South Drive, Pool Lane and Lorretto Drive bore the brunt of the attack. The attacks slackened off and by the end of the year had almost faded away. On 10 January 1942, a German pilot was being harassed by British fighter planes and dropped his bombs over Liverpool to lighten his aircraft for escape. Stanhope Street and Upper Stanhope Street were hit as a result of his actions. Houses between

The Liverpool Blitz Memorial.

No. 111 and No. 119 Upper Stanhope Street took the full force and collapsed. At least thirteen people die in the bombing, all of whom were sheltering within the houses. The street had an air-raid shelter that remained untouched. Sadly, those who lost their lives would have survived if they had been inside the shelter. This night saw the last bombing raids of the Second World War in Liverpool. Upper Stanhope Street was the last street to be hit and, ironically, the Luftwaffe managed to hit Hitler's brother's (Alois Hitler) old house at No. 102. The house was damaged beyond repair and remained in such a state for many years before being demolished. And so the bombing campaign ended, the war carried on and people had other things to worry about. Life was hard, but at least the threat from the skies was gone.

CHAPTER 10

GEORGE RODOCANACHI

I must admit that, like many people from Merseyside, I had never heard George Rodocanachi's name. After reading his story, I felt shocked and ashamed that there is no recognition in Liverpool for the actions of this wonderful man who was born there. The tag 'hero' is often freely handed out, but it fits George Rodocanachi in every way. He was born Georges Constantine Rodocanachi on 27 February 1876 in Liverpool to Greek parents Theodore and Arghyro Rodocanachi. The family was living at the time in Sefton House, Sefton Park, No. 50 Ullet Road, Liverpool. The 1881 census shows that the family were no longer living at this address, by then having moved to London. George was baptised at the Greek Orthodox church of St Nicholas in Berkley Street in Toxteth on 5 April 1876. He may not have spent a long time in Liverpool, but, as his birthplace, the city should be proud that he was one of their sons.

George was educated in Marseille, France, before studying medicine in Paris, where he gained his diploma in 1903. On 22 June 1907, George married Fanny Vlasto at the St Sophia Holy Wisdom church in Moscow Road, Bayswater, London (the Rodocanachi family have a big connection to this church) The following year, on 2 April, their only child was born in Marseille – a son named Constantine. George had returned to Marseille to work as a doctor where he specialized in children's diseases. In 1914, George was working at the Hôpital du Dispensaire des Enfants Malades in Marseille when the First World War broke out; the hospital was quickly adapted to receive the wounded men from the fighting. George decided that he would like to use his medical skills to help the wounded at the front lines and, being British, he contacted the war office in London, which explained that his French diploma would not qualify him as a British Army doctor. He then tried the French Army, who told him that, as he was a British citizen, they could not send him to their own front lines. George then decided that his best option was to apply to become a French national. Once he had achieved this he enlisted into the French Army. George served with the 24th Battalion of the Chasseurs Alpin Regiment, seeing action on Mount Hartmannswillenkopf in the Vosges Mountains of Alsace that overlook the Rhine Valley. The mountain peaks stand between France and Germany and saw some intense fighting during the war, with over 30,000 men losing their lives here.

George Rodocanachi.

George was almost forty when he enlisted into the French Army as a battalion doctor. He would have been at the front treating wounded and sick men, often venturing out into no man's land to recover the injured. If your backs are against the wall then every man needs to fight, there is no other option. George was highly decorated in the First World War, receiving the Legion D'Honneur, the highest award in France. He also received the Croix De Guerre, so he did something that was above the call of duty. He was wounded twice and on one occasion was on the receiving end of a gas attack. George and his regiment remained in the Vosges Mountains until mid-1916, before being sent to fight on the Somme, seeing action at Craonne, Rancourt and La Maisonette. The battalion lost almost half of its men during these times. In April 1917 they took part in the Battle of Ainse that led up to the Battle for La Malmaison, where, in October 1917, the French Army took the town. In 1918 they remained around the Somme region, being listed at Rouvrel and Castle Morisel. In the summer of 1918, they took part in taking the city of Laon, then at Leuilly, Remy, Guise, Seboncourt and Oiys. George survived the war and returned to Marseille and settled back into normal life with his family and his work as a doctor.

George was aged sixty-four when war broke out in 1939, and was too old to be considered for any kind of duty on the battlefields. However, he was determined to do his bit and what he did was nothing short of remarkable. The German Army had occupied France in the early stages of the war, with the country coming under German control, yet a lot of the South of France remained free from occupation. Marseille was still trading with the world and, as a port, it offered escape routes out of France. A lot of people who needed to flee would head to Marseille. In 1940, George had made contacts with the Revd Donald Caskie at the British Sailor's Mission at No. 46 Rue de Forbin, Marseille. The mission was aiding allied servicemen who had not made the evacuation at Dunkirk and were thus trapped in German occupied France. George, who was known by the nickname Rodo, and his wife Fanny, were trusted and brought in to help. He treated any wounded men and they even hid some of them in their own flat. The mission was thought to be the largest safe house in France at that time, receiving anonymous funding, food parcels left overnight on its doorstep and phone calls to warn that police would be checking the building. This shows that a lot of locals knew what the mission was doing and sympathised with those fleeing. The mission would bring the men in and arrange false papers and identities for them. They would take their uniforms, tie them in sacks with rocks, then drop them in the harbour at night time. They would then attempt to move the men through the Pyrenees down to Gibraltar. The mission was very successful, but it came under suspicion and was forced to close. The work, however, continued.

The 'Pat Line', probably the largest escape line for allied servicemen, grew out of the seaman's mission. It was named after Pat O'Leary, a Belgian resistance member whose real name was Albert Guerisee. He had decided to take on the identity of a Canadian serviceman (Pat O'Leary) to protect his family in Belgium. The headquarters for the Pat Line was later moved to No. 21 Rue Roux de Brignoles in

Marseille. This was the home and surgery of George and Fanny Rodocanachi. The Pat Line would help the servicemen by making false identity cards that included their photographs and providing food and shelter until they could be moved. George and Fanny were by now hiding many escaping men in their own flat, where they were asked to wear slippers and not flush the toilet as often as it was used – anything to deter suspicion. The men were not allowed outside, they came from a number of allied countries and most did not know any French. When the time was ready, George or one of the other members would escort them to the station before passing them onto a guide, from here they would be moved via the Pyrenees or by a submarine off the coast.

George was also working on a medical board that consisted of doctors from other nations. Their job was to examine the medical condition of interred servicemen, who, if found to be unfit for any type of future war service, could be repatriated back to Britain. This was an official process and, before Marseille came under occupation, the Germans had used a French doctor to look at the examinations on their behalf. George saw this as his chance to alter and falsify as many documents as he could to get men back to Britain. Once the Germans had arrived and put their own doctor on the board it became almost impossible, but George would still strongly argue their cases. By 1942, the Germans had occupied the South of France and it became more dangerous for the Pat Line members to help the escapees. They continued, but at a slower and more wary pace. Suspicion was a dangerous thing, and with George and Fanny being members of the Resistance they were treading on thin ice. They still evaded detection to those hiding in their apartment, with George running a popular surgery from there for refugees; the numbers coming and going acted as a disguise to other activities that took place there. Between mid-1941 and early 1943, George and Fanny had provided a safe house for over 200 servicemen waiting to be moved out of France. The Pat Line is believed to have helped over 600 escape during the Second World War.

George had noticed the plight of the Jewish people and had set out to help them escape from France. He gained himself the position of examining doctor with the USA consulate for the Jewish immigrants, where he worked tirelessly to ensure the passage to America for as many Jewish people as he could. George realised that the American Government would take sick Jewish people who were not fit enough for the work camps in Germany. He then set about faking documents to make as many of them as he could appear sick and unable to work. George used his skills as a doctor to falsify their medical papers, giving them imaginary illnesses and disabilities. He also called on trusted medical colleges to help him with X-rays, scans and other medical evidence – all false of course. George also knew that he must work at speed to help as many Jewish people as he could, for it would not be long before Marseille was occupied and then it would be almost impossible to get any Jewish people out. The exact number of Jewish people that George Rodocanachi helped to gain passage to America and escape from France is unknown, but it is believed that the total is more than 2,000. These people would have faced persecution, even death, without the help of the kind doctor Rodo.